Chicago's Opulent Age

1870s–1940s

IN VINTAGE POSTCARDS

Cover Postcard
Chicago's spectacular Grant Park and row of skyscrapers are shown as they looked in the 1920s. Left to right is the Colonnade and in the distance, the Art Institute, the Blackstone Hotel, Harvester Building, Congress Hotel, Auditorium Building, New Strauss Building, Railway Exchange Building, Peoples Gas Building, Illinois Athletic Club, Monroe Building, University Club, Tower Building, Peoples Trust & Saving Bank Building, and the Chicago Public Library.

Back Cover Postcard—"The Figures Talk"
Young ladies of the corseted years look at the Big Board of the old Chicago Stock Exchange. They are hoping to find a winner among the numerous Chicago railroad stock offerings. During the 1890s, transportation stocks were risky business indeed due to a climate of too many overbuilt railroads and increasing competition.

Correction for back cover: "Jenny-like" should be "Jenney-like."

POSTCARD HISTORY SERIES

Chicago's Opulent Age

1870s–1940s

in Vintage Postcards

Jim Edwards

ARCADIA

Published by Arcadia Publishing,
an imprint of Tempus Publishing, Inc.
2 Cumberland Street
Charleston, SC 29401

Printed in Great Britain.

Library of Congress Catalog Card Number:

For all general information contact Arcadia Publishing at:
Telephone 843-853-2070
Fax 843-853-0044
E-Mail sales@arcadiapublishing.com

For customer service and orders:
Toll-Free 1-888-313-2665

Visit us on the internet at http://www.arcadiapublishing.com

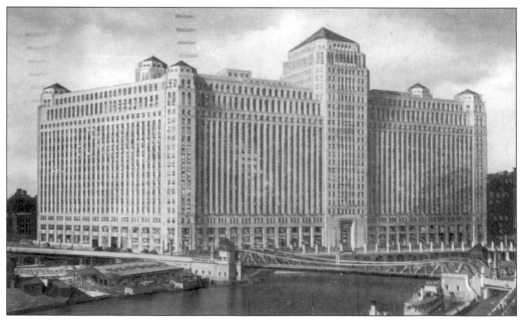

The Chicago Merchandise Mart was at one time the largest building in the world.

CONTENTS

ACKNOWLEDGMENTS

Chicago is one of the great cities of the world. Over the years, I have enjoyed all that the city has to offer—its parks, magnificently scaled buildings, museums, Lyric Opera, and Chicago Symphony Orchestra. It is a city of much complexity and diversity, a place one can return to again and again, and never tire of the offerings. This book is written to, in some small way, repay the city for being so much a part of my life for the last 40 years. If you have never roamed the city's streets, visited its neighborhoods and taverns, and cheered the Cubs, White Socks, Bears, Bulls, or Blackhawks to victory, or sampled its arts scene, you have missed out on some of life's greatest pleasures!

The postcards and other ephemera that constitute the pictorial part of this book came from my personal collection and from that of a good friend, Len Duszlak. Len is as passionate an historian as I have had the pleasure to meet. His collection of Chicago memorabilia is staggering, and his recall of information was a great background source for this book. Betty Kopp Gorshe also graciously allowed me to use a few cards from her collection.

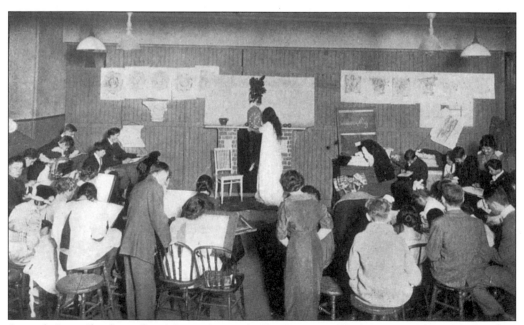

An early juvenile class of aspiring artists at the Art Institute of Chicago is pictured here.

INTRODUCTION

Writing a book about Chicago is a pretty big task, and with only 126 pages and 223 pictures to tell about the city, it is a humbling experience. So much to say, and so little space. It would take a multi-volume set of books to do the city justice, to tell all the wonderful stories, and to show all the photographic treasures of the city's past. A dozen scholars working a decade could probably write a definitive book on the city. The successful authors of Chicago books have always "bit off a piece of the city's history" and run with it. This seemed to be the right way to approach this book.

This book catches a glimpse of Chicago from the time after the Great Fires of the 1870s up to the late 1930s. These were the times when Chicago made no small plans, knew no limits, and nurtured generations of hardworking American millionaires, middle-class, and working-class people. These days in Chicago were very much an Opulent Age—a time when skyscrapers, parks, and pastimes made Chicago the most dynamic and interesting city of the day.

Architecture and Chicago are synonymous. During the Opulent Age, skyscrapers were built only to be replaced later with taller skyscrapers. Over the years, we have lost many of these earlier buildings that should have been saved. The buildings that replaced them tended to be more streamlined and modern, like the dress of the 1920s. We were not building any more elaborately decorated "temple" skyscrapers by then. They went the way of the horse and buggy. Chicago kept right on tearing down, always searching for buildings that would serve its population in better ways.

Postcards included in *Chicago's Opulent Age* tell of a proud city. Every card brags about some aspect of city life. If the postcard was sent through the mail and has a postmark, that date is included in parentheses. The card may have been published years before the postmarked date, but this system will give the reader a general time reference. Addresses were changed in Chicago in 1909, and some of the old addresses are used in the captions. Park names have changed over the years, statues have been moved, and most of the parks have lost their conservatory. Amusement parks faded and were replaced with homes for the city's workers. What "is" used in the postcard narrative may no longer be the case. Today, the recorded image may only be a "was."

Hopefully this sample of Chicago in its first bloom will prove to be interesting, colorful stories that are uplifting, with others that touch on the dark side of Chicago included. The postcards and photographs used in this book were selected because they tell a story on their own, and the narratives were destined to make them even more enjoyable.

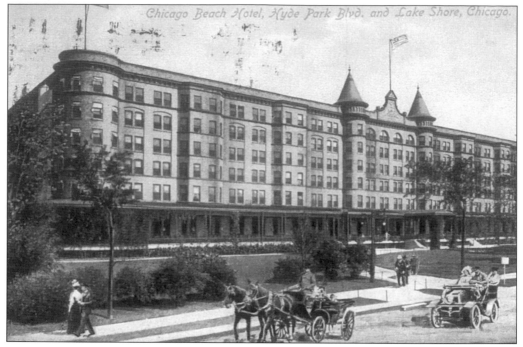

The Chicago lakefront was dotted with large hotels in the beginning of the twentieth century. This is the stately Chicago Beach Hotel on Hyde Park Boulevard and Lake Shore Drive. It resembled a spa hotel with beautifully maintained grounds for strolling. Note the two different kinds of carriages on the roadway. Soon the gasoline, electric, and steam carriages will rule the parkways.

One

TURN-OF-THE-CENTURY CHICAGO

*C*hicago and other American cities erupted with growth after the Civil War. For the first time, the nation, due to increased immigration, had a sufficient supply of labor to run the machinery of industry. American inventiveness was in full bloom, creating new and more efficient machinery. McCormick and others in Chicago were making the city a center for the building of equipment for high-speed farming. Chicago was strategically located at a central point in the nation, perfect for the hub of a vast new railroad network. During most of the two decades before 1900, the economy was strong with only mini panics. Lower prices and expanded production produced a healthy economy, one in which many found themselves moving quickly up the ladder of success. A new middle class emerged in Chicago—skilled, better educated, and with more money than ever to spend on upscale housing. Row after row of turreted three-story mini-mansions began to appear all around the city. Even the working class soon found their American Dream as worker cottages sprang up around factories on the outskirts of the city.

Yet with all the economic and social changes came a dark side; new immigrants faced a city fearful of their presence. They would take jobs away from others, drive down the labor rate, and force their strange ways on Chicago. They were a "menace." Sometimes "they" were Irish, sometimes German. At one time or another, all of the ethnic groups that are today so much a part of the city's rich cultural fabric were treated as outsiders. The usual charge was that they would trigger a socialistic revolution, thereby destroying Chicago's middle and upper classes. Mob actions and riots occurred in 1872, 1877, and 1886, and continued into the next century from time to time.

Chicago's people were deeply rooted in the tradition of the past but equally committed to their newfound materialistic society. They cherished their well-ordered family lives, pretentious houses, and park-like streets, such as illustrated on this postcard which shows residences on Sheridan Road (1908).

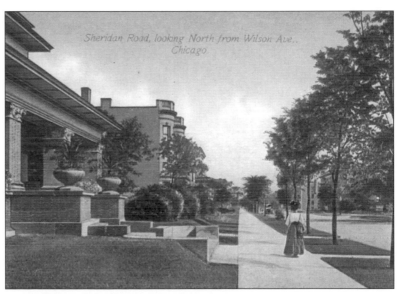

Sheridan Road, looking North from Wilson Ave., Chicago.

The family was the primary social group and was protected at all costs. Families were large in those days, due in part to past days "down on the farm" and a high infant mortality rate. One reason for so many bedrooms in Victorian houses was that many generations of the family lived in one residence. Baby-sitters were right down the hallway where an elderly grandparent or an unmarried member of the family lived.

Children were pampered and protected and given the best that the family could afford. This frilly dressed young girl and her dog pose for the camera with a toy wooden wagon. Perhaps the wagon came from the 1908 Sears, Roebuck & Company catalog, which also sold 23-piece tea sets for girls for 23¢, bisque dolls for $1.29, and small "Teddy" bears for 75¢.

Chicagoans were deeply bound to their churches. Many immigrating groups brought their religion with them and built churches where none had existed before in their new neighborhoods. Most of these churches stressed the idea of angels as guardians to the afterlife and special protectors of children. This postcard shows such a journey to the "judgment throne."

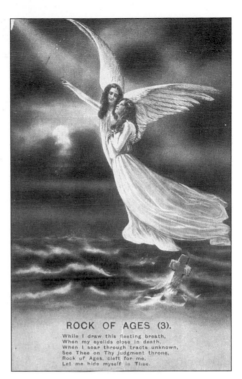

ROCK OF AGES (3).

While I draw this fleeting breath,
When my eyelids close in death,
When I soar through tracts unknown,
See Thee on Thy judgment throne,
Rock of Ages, cleft for me,
Let me hide myself in Thee.

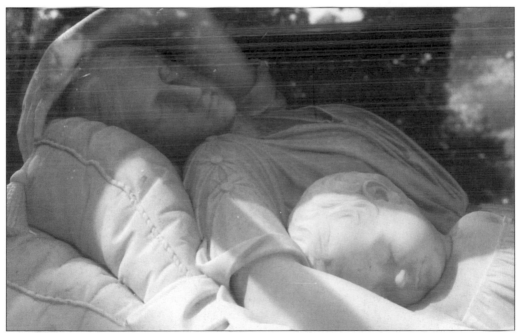

One's social class determined whether you were buried on the hill or on the lowlands. The heights of grave markers gave ready indication as to one's status here on earth. This touching photograph of a dead mother and child was taken in a Chicago graveyard. Etiquette books even gave the proper message to place on the stone. "Herbie: The angels called him on a sunny day, Aug. 15th, 1872. Aged 5 Y's, 5 M's, 4 D's."

Successful Chicago businessmen such as Potter Palmer ran Chicago. His Palmer House Hotel was under construction when the Chicago Fire of 1871 destroyed it and 95 of his other buildings. In 1882, he built his version of a European castle located on what are now Banks and Schiller Streets. Elegant parties were hosted here by his wife Bertha, a woman's rights advocate.

Chicago tried to sober up its citizens by establishing anti-liquor groups in the 1870s, but did not get very far. The Democratic Party's political machine and Mr. Mike McDonald made sure that saloons, gambling halls, racetracks, red light districts, and sporting events were protected. McDonald's gambling hall on Clark and Monroe Streets was only one of the 30 in this area of town!

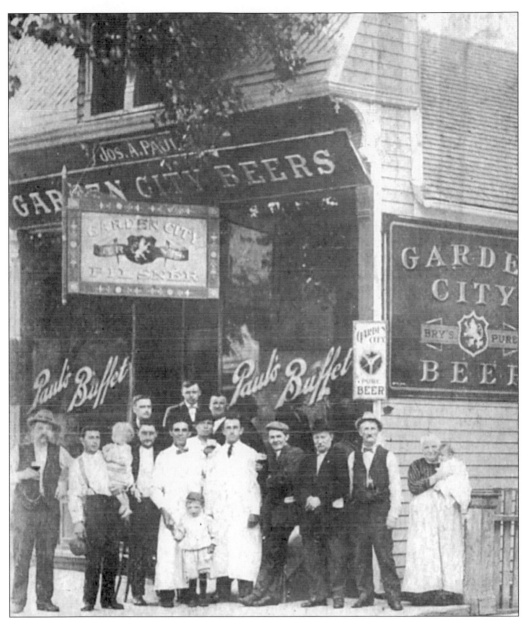

Chicago citizens, rich and poor alike, have always enjoyed their liquor. The rich had their exclusive clubs, while the lower classes had their neighborhood places. Whether they were called taverns, bars, saloons, or watering holes, they were the heartbeats of the community. It was here that all the great and not so great social and political issues of the day were discussed.

The rich had famous clubs such as the Attic Club, a hideout for highbrow artist types such as novelist Hamlin Garland and sculptor Lorado Taft. The club eventually moved to the top two floors of Orchestra Hall and was renamed The Cliff Dwellers.

Ordinary people congregated in the street-level taverns such as the one shown here, the establishment of Joseph A. Paul, which was on the corner of Kimball and Wabansia Avenues (1912). Garden City Pilsner Beers was a local brewery that took the name Garden City after an early name for the City of Chicago.

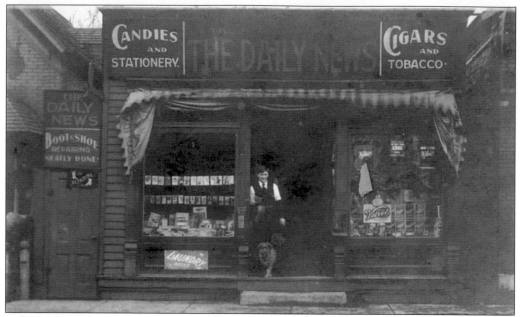

Early immigrants tended to congregate in ethnic neighborhoods and patronize local merchants. Mini-malls or strip malls of today are the closest comparison. This postcard shows Max Weiczor's general store, which was on the corner of what are now Damen and Armitage. *The Daily News* is painted above his front door, along with advertisements for candy, stationery, cigars, and tobacco. In those days, you really could get a good cigar for 5¢!

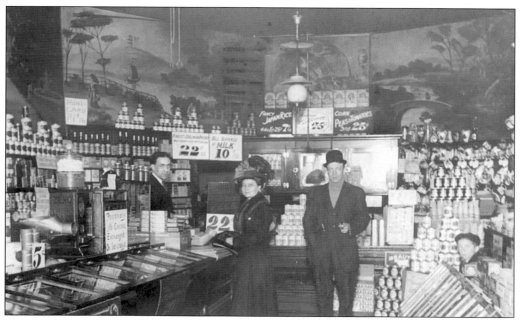

Inside these small general stores were oak glass cases displaying all sorts of general merchandise, such as watches and cigars, while the shelves and floors were used to stack vast quantities of canned goods. Large signs displayed prices such as pure lard at 14¢ a pound, cans of corn, peas, and tomatoes at three for 25¢, packages of Japan Rice for 7¢, and all brands of milk at 10¢ a bottle.

Upper class and middle class Chicago women were fascinated with almost everything that was French, especially Parisian. Whether it was French bygone architecture or the latest fashions, French was in. Today we would call these dresses (also see the back cover) and immense hats restrictive, and those who wore them very much overweight. Ornate valentines were born in this era and were sent through the mail or delivered in person.

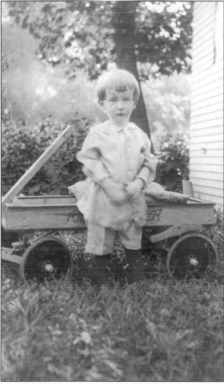

Chicago parents adored their children, and any family without lots of them was suspect. A great deal of a married woman's status among other women was tied to her ability to have a large family. Wide hips and ample breasts were a sign of the day that the woman would be able to perform her "purpose." Toys were just beginning to have brand names, and this view is of a young boy proudly displaying what appears to be a "Radio Flyer" wagon made in Chicago. Notice the wooden hand brake.

Love was constantly in the air in Chicago, and postcards expressing love became a favorite way for a shy male to express what his mouth would not speak to his girl. Kissing cards were very popular, and catchy phrases—serious and not so serious—could sell a card. This card was published in Germany, where many of the most intricate and highest quality postcards were manufactured.

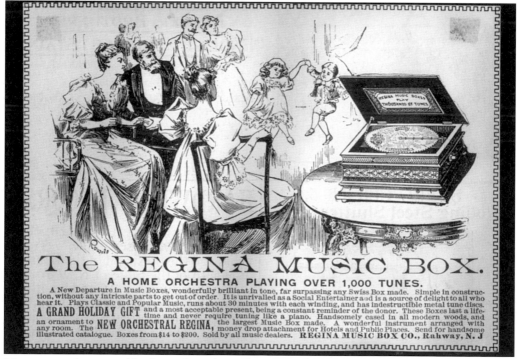

Many a couple courted in the parlor where the two could sit close to each other, always under the watchful eye of a chaperone. Music was sometimes provided by the latest musical invention, the inexpensive music box, which could play interchangeable disc with the latest tunes (1900). The Regina Company maintained a showroom in Chicago and competed with dozens of other makers of such automated musical instruments.

It was generally acceptable in the Victorian Age for married and single men to frequent "Sporting Houses" and "Red Light Districts," where sexual favors were bought and sold. Chicago's most famous whorehouse for the rich was run by the Everleigh sisters. In 1905, Marshall Field's son was fatally shot in their club. The sisters were brazen enough to print a brochure about their services in 1910. Embarrassed city officials had no choice but to close the sister's lucrative business down.

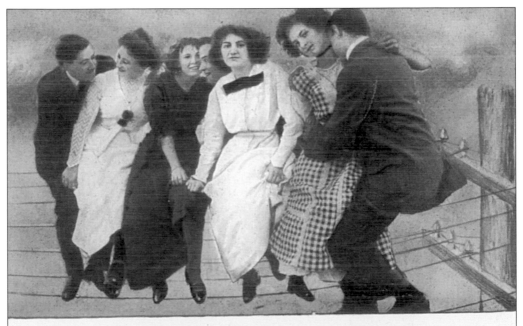

Could not phone, the wires were busy

Here is a 1910 version of "hanging out." Notice the sad girl in the middle without a mate to flirt with. The popularity of the telephone in the home was feared by the older generation if they had courting-age children. Here was a secret way for young lovers to communicate. Later, the automobile would be feared as a "bedroom on wheels" by worried parents.

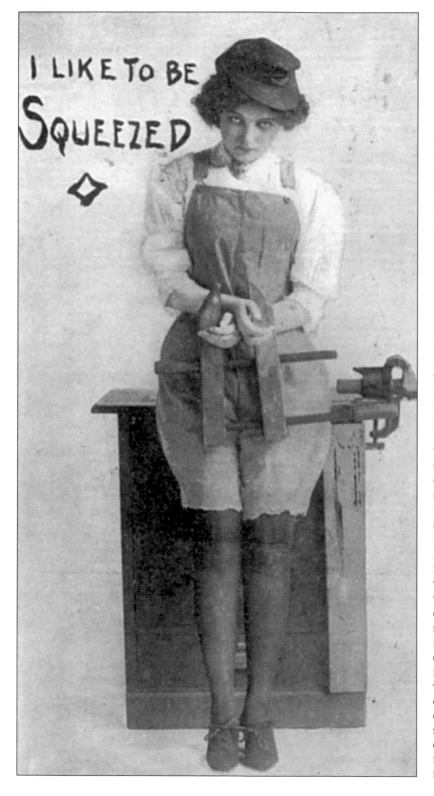

I LIKE TO BE SQUEEZED

Humor postcards appealed to 1900 Chicagoans, especially those with pretty young girls and intriguing captions. Postcards such as this one were not only produced by large companies but also by local photographers who could sell them as a profitable sideline to their business. The young lady dressed as a carpenter, and as such "liberated" from men, still admits "I like to Be Squeezed." Notice that she is holding the wooden vice with her hands crossed in submission. She is also showing quite a bit of leg for her day by wearing cut-off carpenter coveralls. A slightly naughty card in an age noted for being naughty.

Two

SOARING INTO THE SKY

The first skyscrapers, rising as high as 15 stories, were built before the time of Christ. Chicago, however, was the birthplace of modern skyscrapers, which relied on a new type of skeleton framing to achieve the staggering heights. In 1883, William Le Baron Jenney changed forever the way tall buildings were built with his Chicago Home Insurance Building. This landmark building was the first to have Bessemer steel-rolled beams instead of conventional wrought-iron beams, which had been used in Chicago for over 20 years. His skeleton construction method was based on earlier experimentation in Europe. Steel-rolled beams made taller buildings possible, and with the first successful electric elevator's arrival on the scene in 1887, buildings shot further up into the Chicago sky.

From the beginning, the city had faced two major building problems. Its low and swampy terrain made building structures difficult, and the elimination of sewage was a problem. Starting in the 1850s and continuing for decades, buildings were raised and provided with firmer foundations. In 1861, the famous Tremont House, a five-story brick building, was raised 6 feet to a new street grade. After the Chicago Fire of 1871, the city used the debris to fill the low lakefront and to bring more buildings up to an acceptable grade for sewage disposal. After the fire, five- to eight-story buildings began to appear. By the 1890s, new buildings were almost twice that height.

Higher and higher buildings meant better foundation designs. In the 1880s, Frederick Baumann studied footing sizes for buildings and where they should best be located. He believed in dimensional stones of hard lime rock. Other builders used pyramidal footings, shallow footings made of grid work of rails and iron beams, 50-foot oak piles every 3 feet on center, and cylindrical concrete piers called caissons. In 1894, the first "Chicago caissons" were used on the west wall of the old Chicago Stock Exchange Building located at 30 North LaSalle Street. Woodpiles were used extensively along the lakefront under such structures as the Newberry Library (1892) and the Medinah Building (1893).

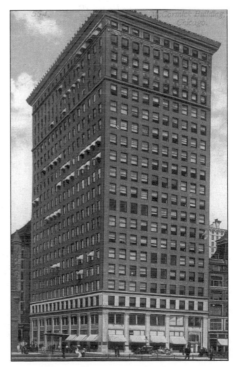

The McCormick Building was completed in 1910, at 332 South Michigan Avenue, and an additional four stories were added in 1912. Holabird and Roche were the architects of this 20-story structure, which has two basements and rests on rock caissons or piers. The first three floors had wide spaced columns to allow for extra window displays, but the limited exterior decoration is only on the upper four-story addition. If you look closely, you can see the original roofline.

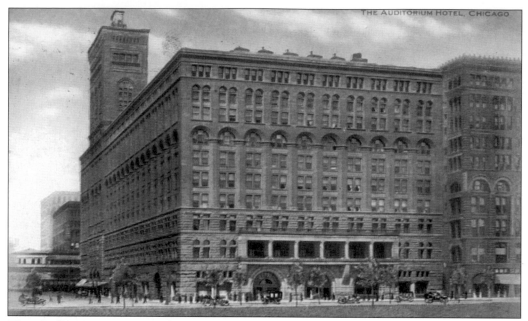

The Auditorium is one of Chicago's greatest architectural gems. At the time of its construction in 1889, it housed a large theater, hotel, and commercial offices. Designed by the firm of Adler and Sullivan, it is a perfect example of what is called the Chicago School of Architecture. It is clad with granite and Bedford stone covering 17 million bricks (1912).

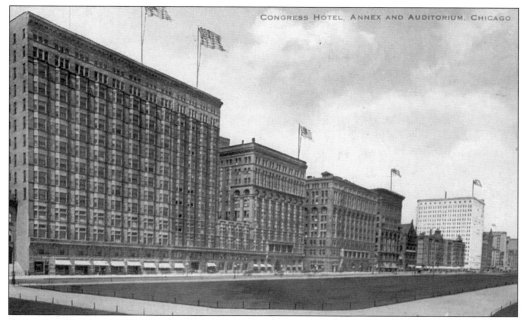

This view shows the Congress Hotel, Annex, and Auditorium. The Annex building, which copycats the facade of the Auditorium, was the Auditorium Annex. The taller part of the hotel has vertical banks projecting oriel windows to allow maximum light into the rooms. The Annex was done in 1893, and the newer part of the complex in 1902 and 1907 by Clinton Warren, Holabird & Roche.

This postcard shows the Railway Exchange Building located on the northwest corner of Michigan Avenue and Jackson Street. D.H. Burnham & Company was the architectural firm that designed this 1904 refined looking structure. Hardpan caissons support the building's 17 floors. Burnham facades are positively streamlined, adding the feeling of greater height compared to the heavily designed exterior of the Auditorium (1905).

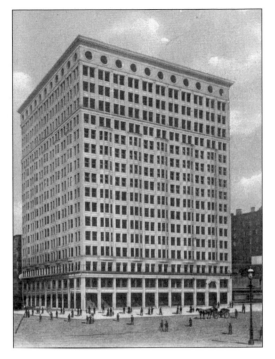

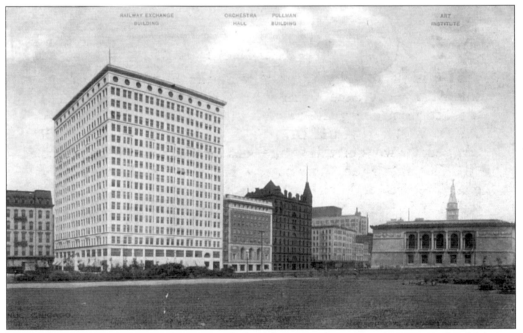

Four of the lakefront's most famous early buildings are shown on this postcard, which was photographed with a panorama and view camera. This camera would photograph from a half circle up to a full circle and make a print possible up to a width of 120 inches. Left to right are the Railway Exchange Building, Orchestra Hall, and the Pullman Building with the Art Institute, originally called the New Art Palace, across the street.

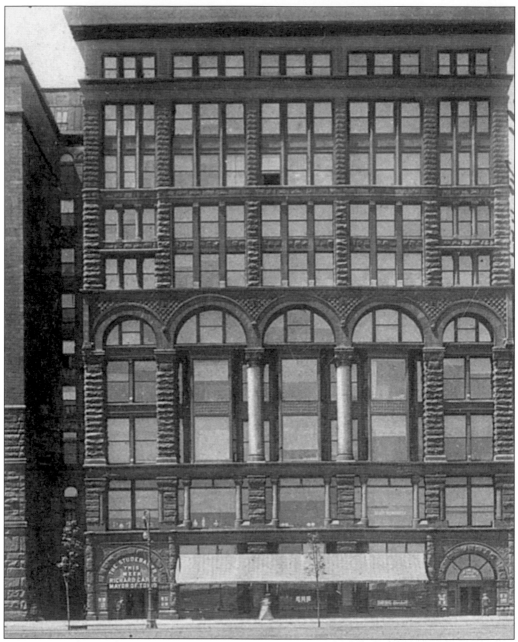

S.S. Beman's building at 410 South Michigan Avenue has served the Chicago arts community well since its opening in 1886. Formerly called the Studebaker Building, it housed a wagon works and showroom. Later, the main floor was converted to a theater. Its outward appearance is like the fusion style of the Auditorium. Murals inside were painted by Joseph C. Leyendecker, who became famous for his Arrow Collar Company ads. John McClutcheon, noted illustrator, and Denslow and Baum of *The Wizard of Oz* fame had studios here at the turn of the century. The upper two floors were added in 1896, and one of these floors serves as an orchestral rehearsal hall. Its interior features rich marble and mahogany wood trim. Inside the entrance to the building is found the message "ALL passes—ART alone endures" (1906).

Fire caused $200,000 damage to the Chicago Athletic Club building just after its completion in 1892. The 10-story building with a basement was designed by Henry Ives Cobb and repaired by him in 1893. The building is constructed with a steel skeleton instead of massive stones. Carl Condid noted that such buildings were like "vertebrate clothed only in light skin." Its extremely elaborate facade was remade in 1907 and again in 1926 (1910).

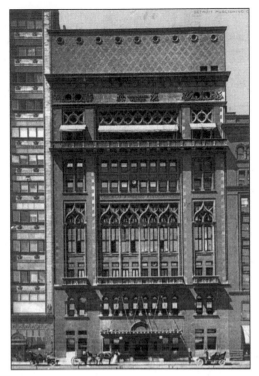

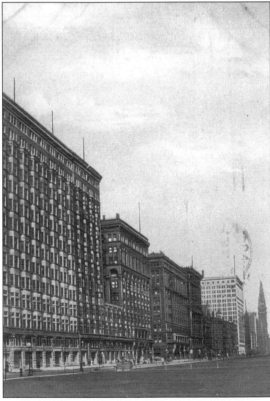

This look down Michigan Avenue from the Railway Exchange Building to the old Montgomery Ward Building shows why Chicago was becoming the skyscraper capital of the world. Builders of such tall structures were not only concerned with saving ground space in the city but also with designing buildings which could offer more light for the tenants. Street level merchants gloried in their new huge picture windows from which they could display their wares.

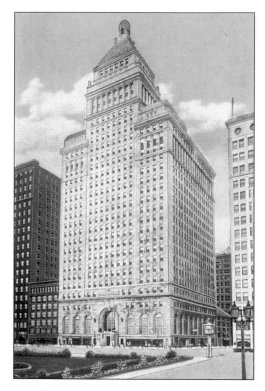

The Strauss Building on Michigan Avenue was at one time the tallest building on the avenue. It was erected in 1824, from a design by architects Graham, Anderson, Probst, and White. The structure is supported by rock caissons and has two basements. Its 21 floors are topped off with a decorative and massive central tower. It was called the Britannica Center in 1993.

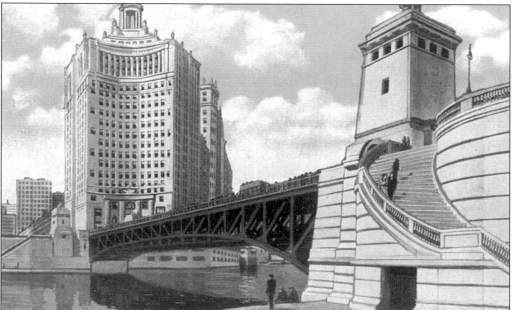

Across the river and bridge on this postcard is the London Guarantee and Accident Company Building. Completed in 1924, it is one of a cluster of magnificent Art Deco buildings in this area. A.S. Alschuler was the architect of this 21-story, rock-caissoned structure. It is Art Deco but with lots of past architectural "noodles." The building resembles a trapezoid. Corinthian columns surround its entrance, and the building is topped with a classic colonnade and domed pavilion!

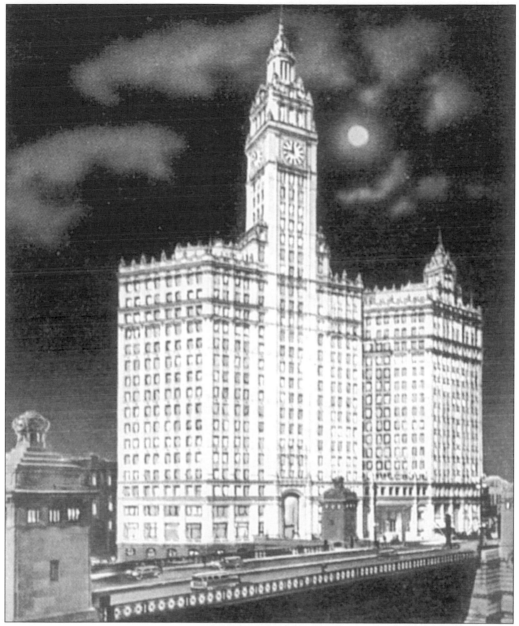

Lit up at night, it resembles a giant decorated white cake. Tribune Tower never fails to attract attention even 75 years after its construction. An Art Deco structure in its internal workings, its exterior is highly decorated, just to be "pretty" (Gothic Revival). This riverfront building was designed by John Mead Howells and Raymond M. Hood, who won an international design competition held in 1922 by the newspaper.

The building resembles a cathedral with its tall center tower. The tower is 36 stories tall with four basements resting on rock caissons, and it is the seventh building to house the newspaper. Tribune Towers and Tribune plant covers 11,496 square feet. It took three years to complete at a cost of approximately $3,000,000. The Tribune Clock Tower is Chicago's answer to London's "Big Ben."

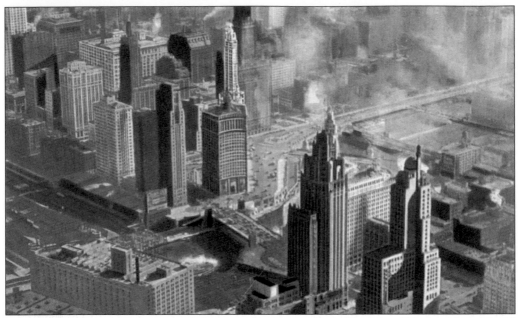

This postcard shows a sky view of the magnificent "towers" along the Chicago River. David H. Burnham, legendary Chicago architect and city planner, once said, "Make no little plans; they have no magic to stir men's blood." Chicago used his plans and took his advice to heart as evidenced by this spectacular view of some of Chicago's tallest skyscrapers (1942).

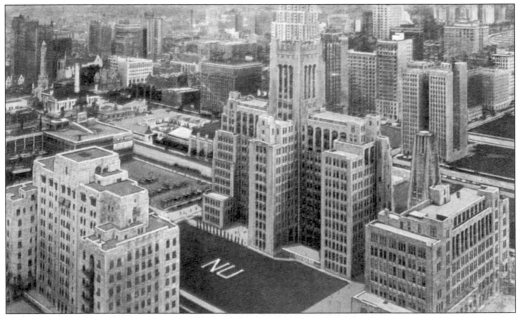

This is another sky view card, this time of the McKinlock Campus of Northwestern University in Chicago. This complex of Art Deco buildings were designed by various architects and built between 1926 and 1932. The key building on the campus was the Montgomery Ward Memorial, which housed the medical and dental schools of the university. This structure was completed in 1926, with 14 stories and a five-floor tower on the top.

When the Monadnock Building opened in 1891, it became the "King Kong" of Chicago's commercial office buildings. Designed by the famous team of Burnham and Root, the street facade was designed in an Egyptian manner, calling attention to the similarities between lower Egypt's and Chicago's soggy and marsh-like riverbanks. Ornamentation is refined. At the base of the building are papyrus bud shapes, and above them are projecting bays that resemble a field of papyrus plants. Frank Lloyd Wright made much to-do with the concept that buildings should be one with the land or organic architecture. Here Burnham and Root applied this concept to their building. At 16 stories high, this building was not exactly high-tech for its day. Masonry supports the upper floors, making walls 6 feet thick at the base necessary. The building attracted five railroad tenants by 1893, and had the world's first aluminum elevators. Holabird and Roche designed the steel-framed terra cotta (fire proofing) clad southern building addition.

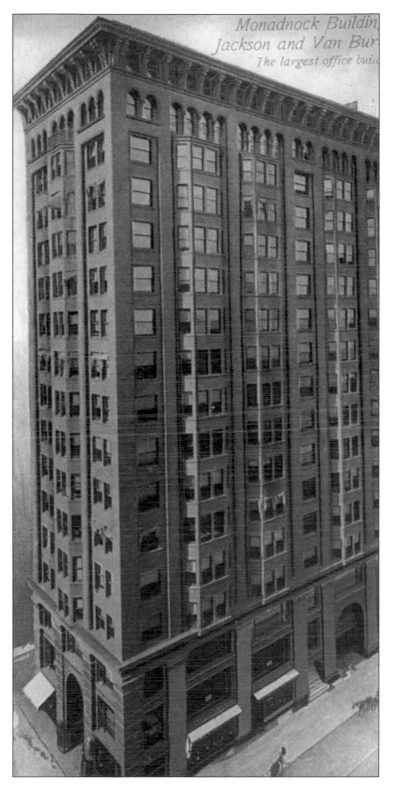

Monadnock Buildin
Jackson and Van Bur
The largest office buil

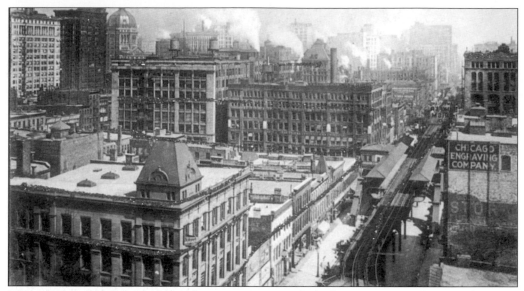

This aerial postcard shows Loop skyscrapers, many of which were supposedly made fireproof by the use of this glazed bricks. Buildings clad in these bricks became knows as China Fronts. These bricks were also popular because they were inexpensive and had the appearance of marble. Today many of these terra cotta bricks are falling from the buildings, endangering pedestrians.

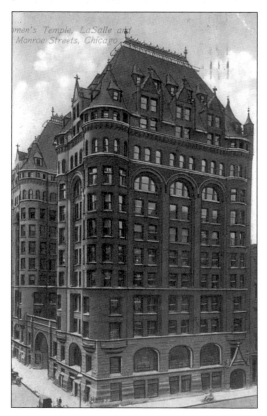

Chicago's "Queen of Temples" at the southwest corner of LaSalle and Monroe was another classic Burnham and Root building, constructed in 1892. Willard Hall, which could seat 700 people attending meetings of the Women's Christian Temperance Union, was on the first floor. This building was steel framed and "H" shaped. Burnham and Root designed it in the Gothic/Romanesque style. This building was demolished in 1926 (1910).

The Heyworth Building was built in 1905, at 29 East Madison Street as a 19-story structure on caissons. The design by the firm of D.H. Burnham & Company (note, no Root) featured a Romanesque commercial style, which was becoming very popular at the turn of the century. There was one wide arched entrance with huge windows. This building is a forerunner of the all-glass-clad buildings of the future.

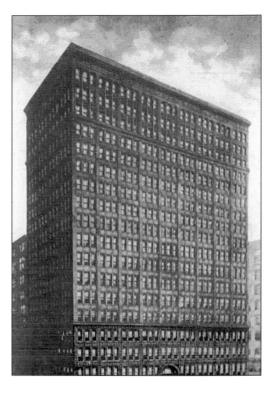

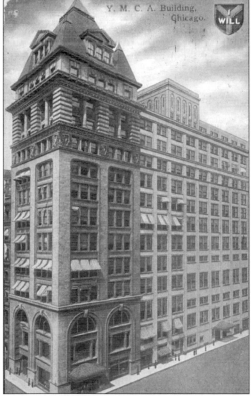

The YMCA building was erected in 1893, at a cost of $850,000. It fronted on LaSalle Street and was 190 feet high with 12 floors and an elaborate 16-story tower. Jenney and Mundie were the architects. The building had a spread foundation and steel beam grille system, and was an interesting blend of old-time romanticized architectural styles and newer plain facade work.

29

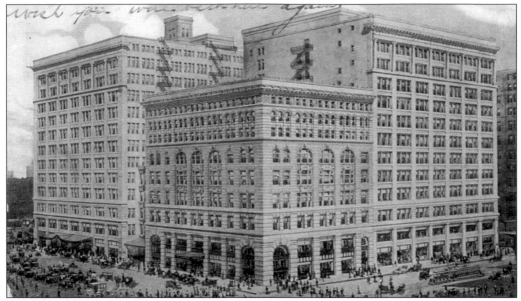

Marshall Field & Company's State Street store is shown on the above card. It is actually a series of buildings constructed or reworked in 1892, 1906, 1907, and 1914! At the center of the complex is the 1893 commercial Romanesque styled building designed by Charles Atwood. Other structures in the block are more simplistic. One of the buildings in the complex was designed by D.H. Burnham & Company.

Inside this palace of shopping pleasure was an atrium topped with a Tiffany dome. "Give the Lady What She Wants" became the watchword of this landmark department store. The store had hundreds of departments, which were each like stores in themselves. One could get lost in this immense building. Below is an advertising postcard from Fields touting its flag section, oriental rug section, and Indian goods area.

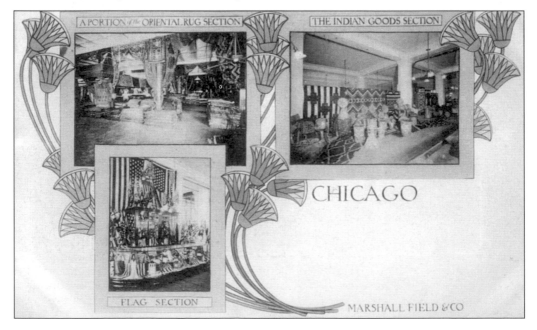

The new Commercial National Bank building was on the northeast corner of Clark and Adams Streets. Completed in 1906, it was yet another building designed by D.H. Burnham. This building was an 18-story, two-basement building resting on rock caissons. Later it was known as the Edison Building. The lower floors had impressive columns, and the top floors had arched windows.

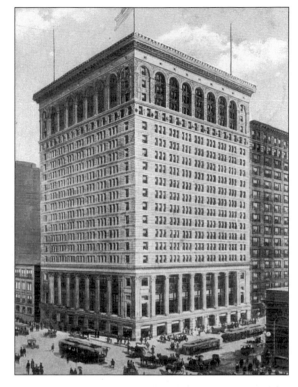

The Boston Store at North State, West Madison, and North Dearborn Streets was like Marshall Field, a work in progress. It was planned by the firm of Holabird & Roche and was built between 1905 and 1917. The tallest portion was 17 stories tall. In 1949, the store was liquidated, and the building was renamed the State Madison Building (1913).

This night view postcard is a striking look of the North American Building, which was built in 1912 at 36 South State Street. Holabird and Roche designed this 19-story building, which had three basements and rests on rock caissons. The site was once occupied by a four-story Lyon and Healy music store and a later six-story building (1914).

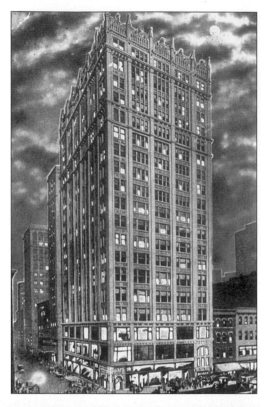

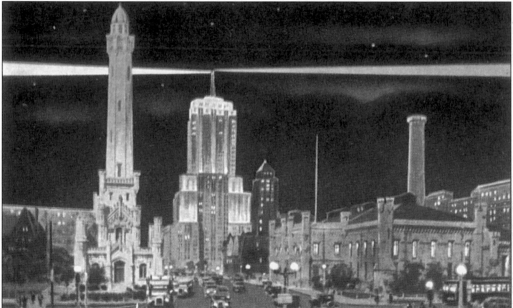

Another night view card shows the Water Tower and plant as well as the Palmolive Building. The Palmolive Building was completed in 1930, from designs by Holabird and Roche. Like its sisters, the Lyric Opera Building and the Stock Exchange, it is a multi-tiered streamlined building. On top is a 150-foot warning beacon named in honor of Charles A. Lindbergh.

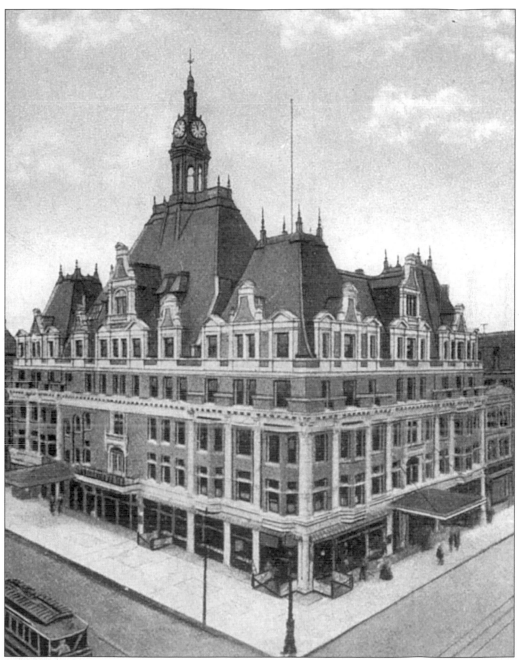

The Bush Temple and Museum was built on the northwest corner of North Clark and West Chicago. Architect John O.E. Pridmore designed the building, which was completed in 1901. Its six floors and one basement were home to a music school and museum. The elaborate French styled mansard roofs would have been more at home on a Parisian street, but upper-class Chicagoans at the turn of the century were enamored of all things French, and they enjoyed this illusion of Paris. The building was last known as the Chicago-Clark Building. Notice how wide the sidewalks were at that time in Chicago with trolley service available for downtown shoppers. This postcard was printed in Germany (1908).

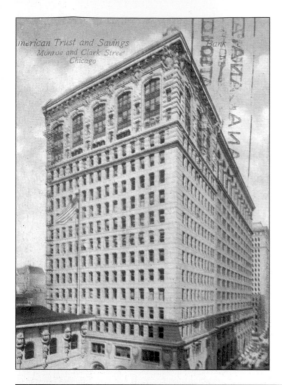

The American Trust & Savings Bank, located on the corner of Clark and Monroe, is a building designed to house a bank on the lower floors. It was built in 1906, from a design by Jarvis Hunt. The second bank to occupy the site was called the Fort Dearborn Bank. Three architectural styled layers are evident in this 17-story building. The upper section is very decorative with elaborate medallions all along the roofline (1912).

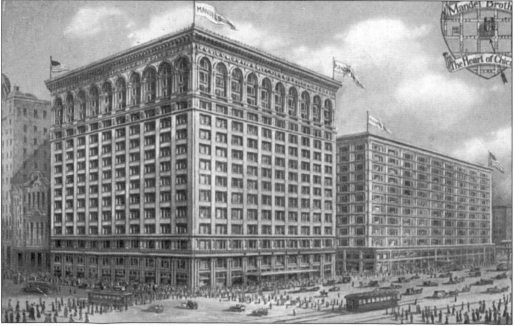

Mandel Brothers store, on the northeast corner of North State and East Madison, was designed by Holabird and Roche between 1900 and 1912. The first of this store's buildings was a nine-story structure. Two floors were added later. The 12-story building section was completed in 1905, and the 15-story section in 1912. Later Wieboldt's Department Store was located here. Notice the use of American flags and Mandel Brothers flags on the corners of the roofs!

The building to the extreme right is the old Chicago Board of Trade, erected between 1882 and 1883, at a cost of $1.8 million. It had eight elevators and a central clock tower with a bell that weighed 4,500 pounds. Its exterior was covered in Maine granite and 90,000 enameled fireproof bricks. Inside the nine-story structure was an 80-foot hall with a stained glass skylight. To the left were the Phoenix Club, Hotel Grace, and the Union League Club.

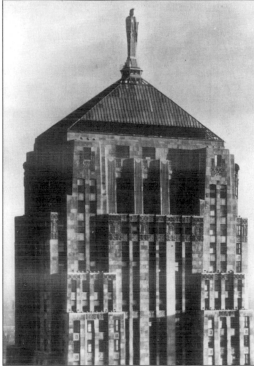

Holabird and Root designed the new Board of Trade building, which was completed in 1939. It is the tallest dominating building at the end of the "Grand Canyon" of LaSalle Street. The Art Deco faceless statue of Ceres (Roman God of Grain) tops this magnificently tiered 54-story building. Architect Helmut Jahn fiddled with the building in 1983.

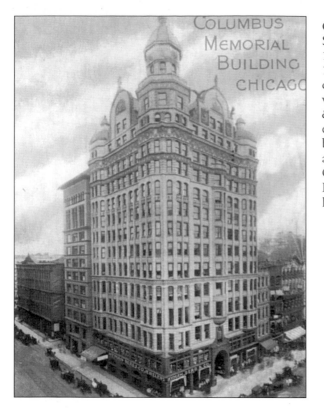

Columbus Memorial Building at State and Washington was erected in 1892, in time for the World's Fair of 1893. It was a million-dollar commercial, 15-story structure, which had the firm of Hyman, Berg & Company jewelers occupying its entire first floor. It was touted as being a "new style of architecture" and "the richest looking" of Chicago's new steel skyscrapers. Inside was a free reading room and library (1904).

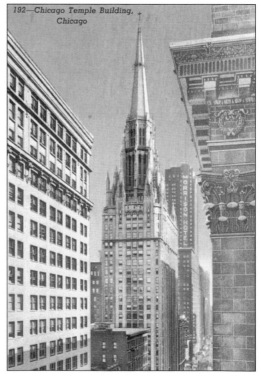

The First Methodist Church was built in 1923 by the "Tower Kings" Holabird and Roche. It claimed to be the world's tallest church. Most of its 21 floors, however, housed offices. The top of the building has a neo-Gothic steeple and chapel. The church also maintains a first-floor sanctuary. This one-of-a-kind "Cathedral" building is located at the corner of Clark and Washington. Medieval cathedrals were the skyscrapers of their age (1944).

Aaron Montgomery Ward came to Chicago in 1865, and worked as a clerk at Field, Palmer, and Leiter. Seven years later, he had his own mail-order house in the loft of a Chicago barn. Later, he bought property on Michigan Avenue and built the store shown at right. Ward was disgusted with the view to the east of his store. The lakefront included not only ugly railroad yards but also dumping grounds, old cemeteries, and armories at this time. For 13 years, he fought to clean up the riverfront and make it into a park. Below is a postcard showing Ward's landmark warehouse billed as the "largest concrete building in the world." Constructed in 1899–1900, it used a steel frame with a 50-foot woodpile foundation. It was built as a 12-story building, which would hold four additional floors. The facade of the lower three stores is of Georgian marble. The tower was 12 stories at one time and included a 22.5-foot weather vane. Richard E. Schmidt was the architect.

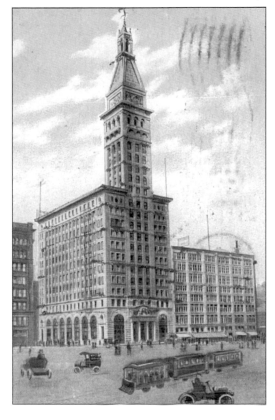

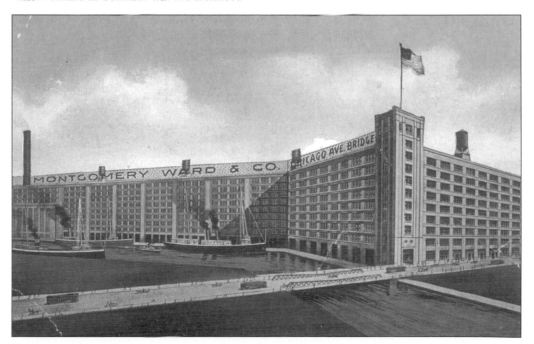

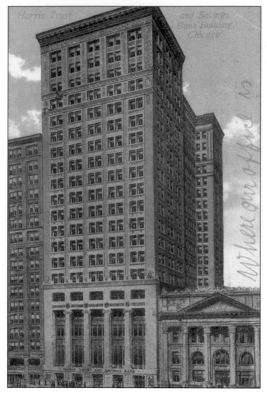

The Harris Trust Building, located at 111–119 West Monroe Street, was built in 1911. A 20-story building with three basements, constructed over rock caissons, it had high and impressive Greek columns, which were long associated with banking and financial institutions. The structure was designed by the architectural firm of Shepley, Rutan, and Coolidge. Decorations were reserved for the lower and upper floors.

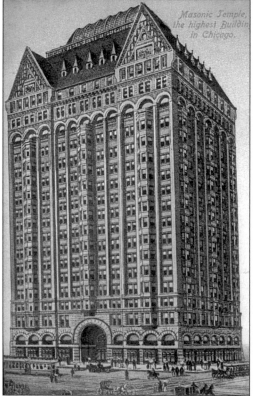

The reigning king of the world's skyscrapers in 1892 was the Masonic Temple on the northeast corner of Randolph and State. A Burnham and Root masterpiece, it was the first 20-story building in Chicago. The Masonic Temple served as a final testament to overblown Victorian taste. The rotunda on the main floor was open to the skylight at the top. It cost $3.5 million to build and had a roof garden and a basement restaurant that could serve 2,000 people, as well as 14 elevators and 543 offices.

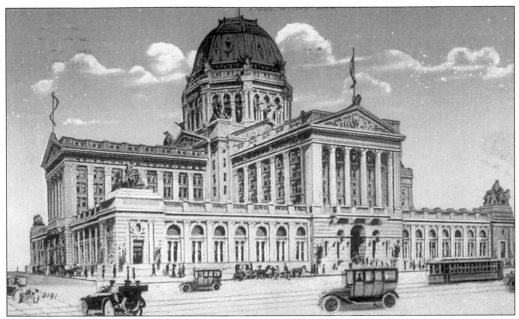

This postcard shows the old post office and federal building, which took up an entire city block at Clark, Adams, Dearborn, and Jackson. It was completed in 1905 at a cost of $4,757,000. It was constructed on a 76-foot-deep foundation. The main building was eight stories with a dome section another eight stories high. The exterior was an eclectic blend of Greek, French, and Roman styles with rooftop porch decorations.

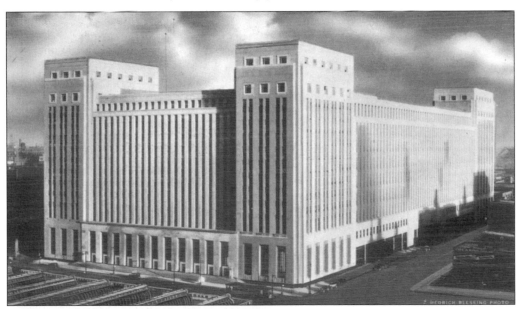

The new post office building at 433 West Van Buren was said to be the largest post office in the world in the 1950s. Located on the Chicago River, it is 800 feet long and 350 feet wide. On its 21 floors were 10 miles of conveyor belts, which handled 35,000,000 letters and 500,000 parcels a day. To move all this mail took over 11,000 workers. The structure is a typical modern building with a plain exterior, with vertical lines created by the window openings.

This postcard view was taken from the top of the Medinah Athletic Club looking south down Michigan Avenue from the Chicago River. Tribune Tower is on the left, and the London Guarantee and Accident Company Building is on the right. This view shows the great diversity of building styles located in this part of the city. A recent list of landmark buildings in the downtown area includes 18 structures.

Following the Opulent Age, Chicago skyscrapers began to look like tall glass boxes on short legs. Many old buildings were wrecked and replaced by the sleek, yet character-less, buildings. Only in the 1990s did architects begin to design buildings for the downtown that fit the architectural heritage of their surroundings. The new Harold Washington Library is a new beginning for Chicago. At least the taller glass skyscrapers reflect, and therefore steal, the images of the old skyscrapers still left in their midst.

Three

PARKS FOR
PROMENADING

*C*hicago did not make small plans when it began its park building spree. In the later part of the nineteenth century, park building went hand-in-hand with the construction of new housing for the rich and near rich of the city as well as for the redevelopment of the lakefront. Parks provided the necessary breathing space for the compacted Loop and beyond. Each park had an ethnic clientele because of the way immigrants tended to live in one neighborhood. New upscale middle-class neighborhoods also had their own parks. The name of the park and the statuary gave clues as to which ethnic group walked its paths. Statuary honored nationalistic heroes as well as old world heroes such as Schiller and Goethe. By the time of the World's Fair of 1893, Chicago's park system was in all its glory, all decked out for the thousands of visitors.

Andreas Simon, author of a book on the city's parks, called them "the lungs of this great city." He noted that they benefited both the carriage trade and "those who between Sundays and holidays are huddled together in dingy quarters." John Thorpe, who was in charge of floral planting at the Fair, said that each Chicago park had a special feature. Humboldt Park was rich in natural landscaping, and Lincoln Park had superb water effects. Washington Park had great flowering and bedding plants year-round.

Over the years, Chicago's parks have been dissected to make room for more roads, statues have been relocated, greenhouses dismantled, and conservatories demolished, but the parks live on and continue to fulfill their purposes for which they were established so many years ago. One writer said it in just a few words, "The parks are useful, because they add to human enjoyment."

The Ivan Mestrovic Indians on horses with drawn bows formerly guarded a graceful plaza in front of Buckingham Fountain, but they now aim their arrows out over cars and busses on the extension of the Congress Parkway, which cuts through Grant Park.

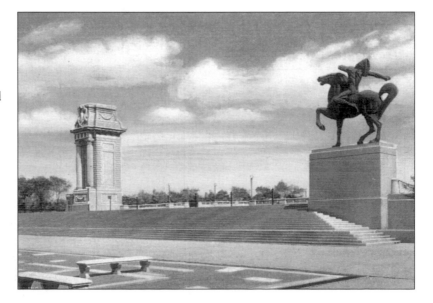

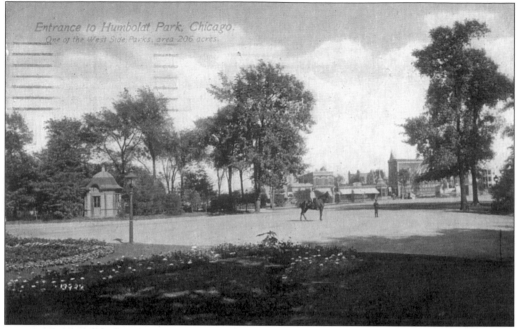

Humboldt Park was the largest of the West Side parks during the Opulent Age. Its 206 acres contained large pavilions, pergolas, and terraces, below which was a lake and boathouse. The park was opened to the public in July of 1877, to serve the many Chicagoans of German descent who lived on the Northwest Side. Opening day activities included a traditional "Volksfest."

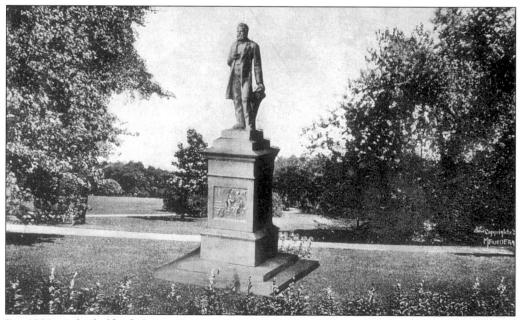

By 1891, only half of the park was completed. The state legislature raised $220,000 to complete the park, adding a new 31-acre lake, building a casino, music pavilion, and boat landing. Park goers were informed in 1892 that the park would soon have another statue of a German "native son" Fritz Reuter, the Charles Dickens of the Plattdeutsche people.

Humboldt Park was named for Alexander von Humboldt, a German naturalist and scientist. Two hundred thousand people were in attendance when the bronze statue of Humboldt was unveiled in 1892. Felix Goerling's 10-foot-tall statue in the park was cast in Germany. Mrs. F.J. Dewes, a prominent Chicagoan of German heritage, paid for the work.

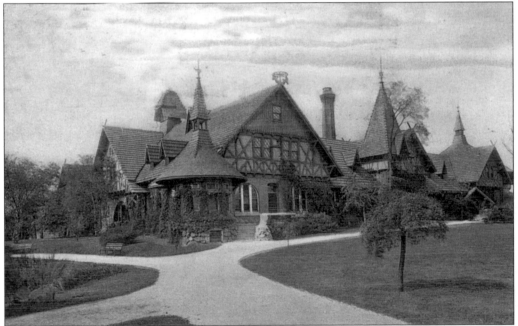

Humboldt Park had a beautiful entrance building, called at the time a Receptory. The structure looks as it had been lifted from a German site and brought to Chicago. The multiple steeples and waddle and daub facade of the Receptory help to give the building its old world charm.

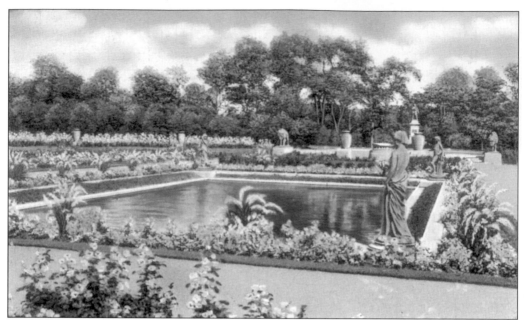

This postcard view of the Humboldt Park sunken garden shows the extent to which the park was filled with huge urns and animal and human statues. Roses and ferns are in abundance, as well as four bronze statues by Leonard Drunelle. For years, the park maintained a walkway lined with thousands of violets, the state flower (1939).

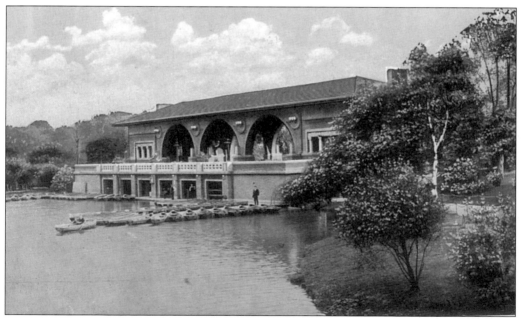

Boating was a popular attraction in the Opulent Age. Shown in this view is the Refectory, a dining building, and Humboldt Park's boathouse. Notice the canoe pier. Also of interest at the park was a water court and music court (1926).

Following the death of President Garfield, Central Park was renamed Garfield Park in his honor. The park is about midway between Humboldt and Douglas Parks. Its 185 acres had a 17-acre lake with two small islands. This is the south entrance from Madison Street. Note the two sculptures that are next to the walkway.

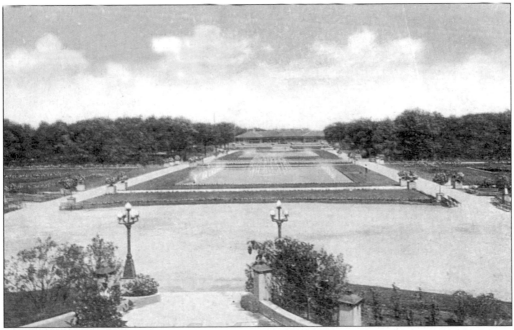

Garfield Park's fountains and flowerbeds were modeled after classic European parks and were most elegant. In 1875, there was a driving park, but this was later changed to lawns for baseball, cricket, and other outdoor sports. Raised planters were found on every corner of the park's wide walkways.

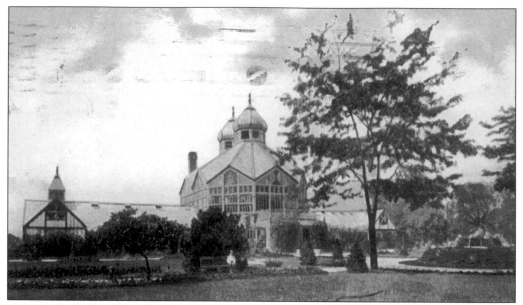

Garfield Park's old conservatory, a building used to grow and display plants and flowers, was a masterpiece of high Victorian architecture. This one was well known for its collection of orchids in the 1890s. Conservatories were popular attractions for the parks all year long.

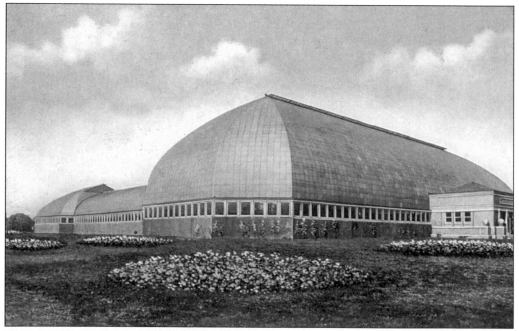

This view shows the new Garfield Park Conservatory which, in 1910, was billed as the largest in the country. It was a graceful looking large structure but lacked the charm of the old conservatory (1910).

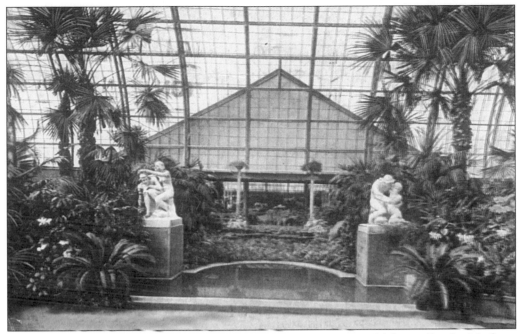

Shown in the postcard is the entrance to the new conservatory, which was lined with ferns and palm trees. Sculptured nude frolicking couples are beside the reflection pool, once again calling attention to the importance of statues in Chicago's parks. These two statues appear to be Larado Taft's *Pastoral* and *Idyl* (1912).

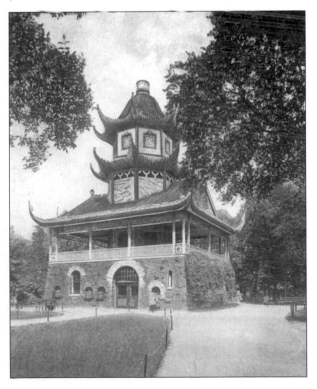

Garfield Park began to really sparkle when Jens Jensen became its landscaper at the turn of the twentieth century. Jensen installed a rose garden with three pagodas and reworked the shape of the lagoon. This oriental pagoda was the most elaborate one in the park.

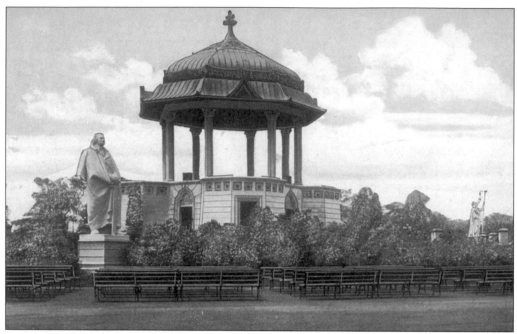

This interesting pagoda was used for band concerts. It was circled with statuary, including one from the World's Fair of 1893, shown on the right in this postcard. The park also had an artesian well, which contained "medicinal properties for stomach and kidney diseases."

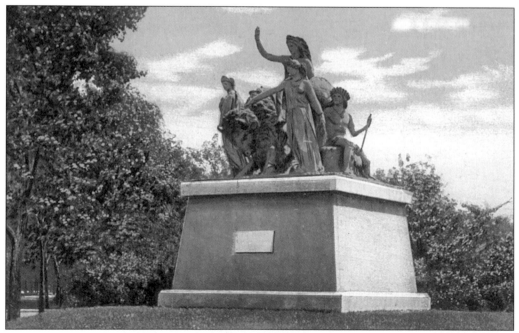

Many of the city parks had statues of Native Americans, usually depicted as noble savages. This sculpture depicts Native Americans as idealized neo-Greek figures. As late as 1893, the park board had still not erected a statue to President Garfield.

The land which became Lincoln Park almost became a permanent cemetery. In 1864, the Chicago City Council planned a park, to be called Lake Park, on 60 acres north of a cemetery. After that, over 500 paupers were buried in land south of the cemetery. The two areas became Lincoln Park in 1865.

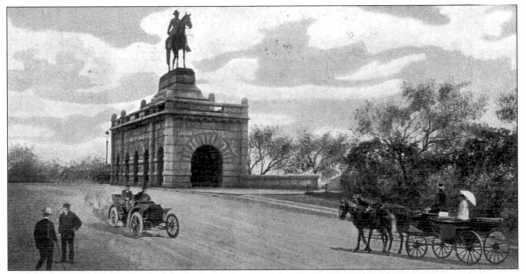

Joining the above statue of Lincoln by Augustus St. Gaudens, which was unveiled in 1887, was a massive monument to U.S. Grant, Civil War general and president. This stone-based bronze was erected after over 100,000 people contributed to its cost. The statue was designed by L.T. Rebisso and unveiled on October 7, 1891. Mrs. Grant was at the dedication (1911).

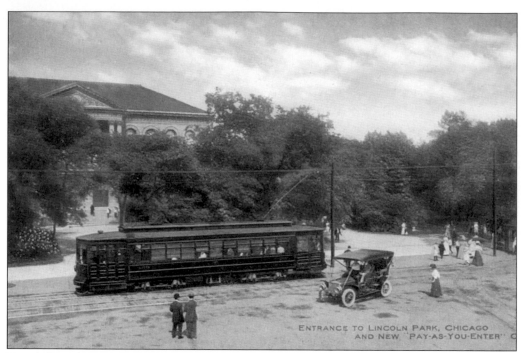

ENTRANCE TO LINCOLN PARK, CHICAGO
AND NEW "PAY-AS-YOU-ENTER" C

You did not have to go to Egypt or London to see sphinx. Lincoln Park had a female sphinx guarding the park entrance. By 1908, the park was 514 acres. Lincoln Park had a large German influence, with statues such as that of Friedrich Schiller, Germany's great poet, which was presented by the Swabian Society in 1886.

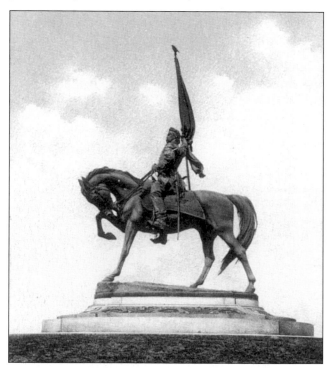

The General Logan Statue in Lincoln Park was a 1897 work by St. Gauden. It is on a man-made hill. "Black Jack" Logan was a Union commander who defeated Confederate commander John Bell Hood outside of Atlanta. Logan wrote a history of the war, called *The Great Conspiracy*, and served in Congress.

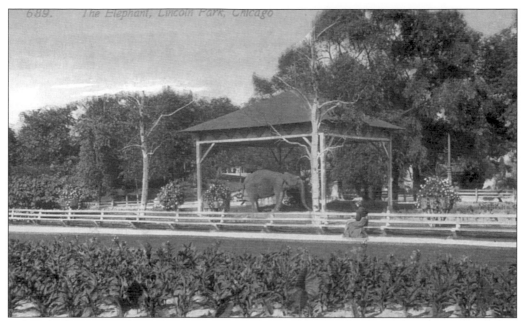

"The Elephant, Lincoln Park, Chicago," is the only inscription on this *c.* 1900 postcard. The park did have only one elephant even in 1893, but it also had two African lions, five monkeys, ten buffalo, fifteen crocodiles, seven white swan, thirteen bears, three rattlesnakes, and other assorted zoo animals.

This rare early postcard shows the cage for Lincoln Park's 18 eagles. Also in the park were seven buzzards, eighteen owls, three magpies, four parrots, three cockatoos, twelve ring-doves, nineteen peacocks, three pheasants, four quail, two cranes, and three hawks (1906).

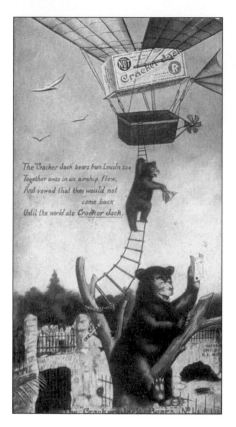

The bear compound at Lincoln Park is shown in the background on this Cracker Jack postcard. This was one of 16 beautiful postcards that were sent free to anyone who mailed in 10 sides of Cracker Jack packages reading, "The More You Eat, The More You Want," to Rueckheim Bros. & Eckstein, Chicago (1907).

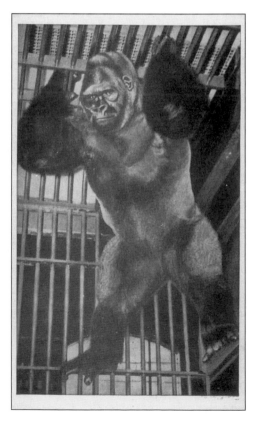

Lincoln Park became internationally famous beginning in the 1930s because of one animal, Bushman. Bushman, the gorilla, was captured in equatorial West Africa in 1929, and sold to the zoo the next year for $3,500. When he arrived, he only weighed 30 pounds. At maturity, he was the largest captive gorilla in the world, standing 6 feet, 2 inches tall and weighing 550 pounds. A vegetarian, he ate 22 pounds of food each day.

Jackson Park had a handsome iron bridge that connected to the Wooded Island. Boating, as in all the parks, was one of the biggest attractions. Electric launches also went back and forth from the Wooded Island, charging 10¢ for a round trip. The park's many lagoons are a remnant of the 1893 Fair (1913).

Jackson Park was originally named Lake Park in 1875. One of the reasons that this park was so popular was that it was "exempt from factory smoke or foul smells" of the city's factories. It was a perfect site, therefore, for one of the first golf courses in Chicago. This postcard is captioned "Jackson Park, Golf Link."

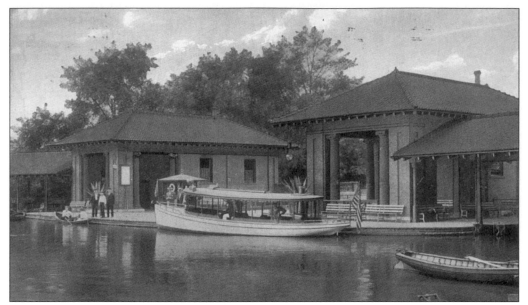

This view shows the boathouse and what appears to be a steam launch used to transport people to various parts of the park. Rowboats and canoes are known to have been used in the park. There were also canopied paddleboats for six people available for rent.

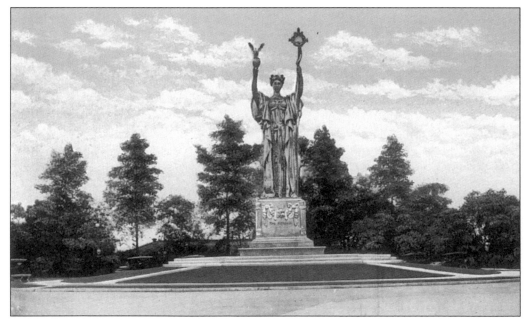

The Republic statue from the World' Fair, depicted on this early postcard, should be familiar. It was seen on a card from Garfield Park on page 48 in the upper view! This card from the 1930s shows it as being returned to its original site in 1893 (1933).

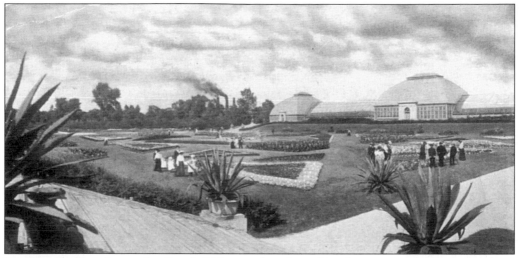

Washington Park is on the South Side running from 51st Street to 60th Street between Cottage Grove and South Park. It has 7 miles of driveways, walks, and bridle paths. Shown here is the park's spectacular Flower Garden and Conservatory (1909).

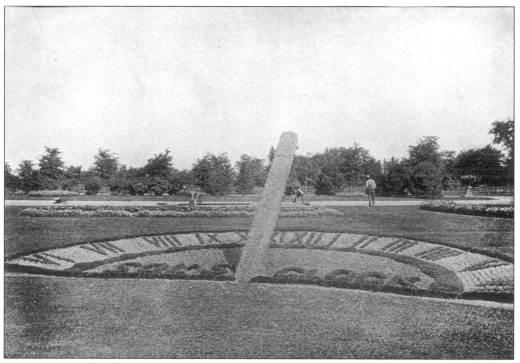

The park was famous for its floral Sun Dial, shown in this view, and for a floral Gates Ajar, in another part of the park. Washington Park was totally surrounded by residences. A huge draw for the park was the running of the Great American Derby at the Washington Park raceway each year. The large grandstand held thousands of race fans.

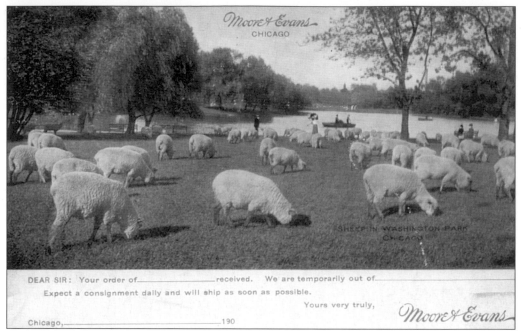

Before Cows on Parade in Chicago, Washington Park had live Sheep on Parade, *c.* 1900. This clever advertising card was used by the firm of Moore & Evans to notify their customers that they were out of stock for an item(s). Sheep were used as lawnmowers in the park (1900).

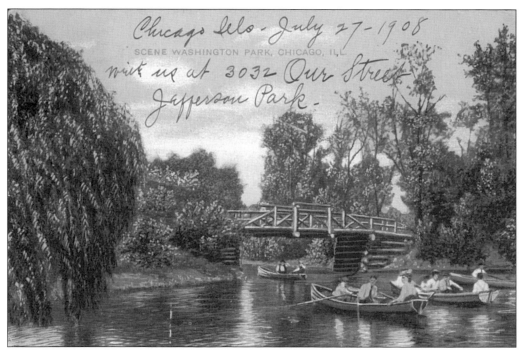

The rowboats shown here could be rented at Washington Park in 1909, for 15¢ an hour. Shown in the background is one of the most unusual bridges in the park, constructed of logs using old-fashioned engineering practices. The park also had tennis courts and a baseball field.

The seal pond was one of the favorite attractions at Lincoln Park. In this card we see a large crowd leaning on the pond's fence. Andreas Simon, in his 1893 book *Chicago, The Garden City*, does not mention the park at that time as having any seals, so it might be that this amusement was added later but before 1905 (1905).

In 1908, this impressive Greco-Roman building in Lincoln Park was called the Science and Arts Building. Founded in 1857, this is the city's oldest museum and the oldest scientific museum in the west. Matthew Laflin, an early Chicago businessman, decided to fund a building that would bear his name when he discovered he could not be buried in Lincoln Park.

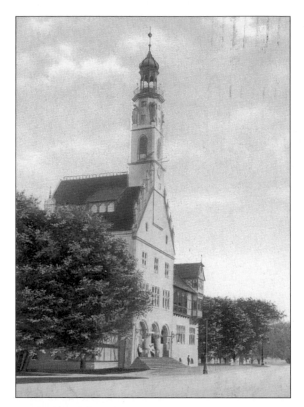

With the waters of Lake Michigan to its back, Jackson Park was a Mecca for park-hungry South Siders. Located 6 miles from the Loop, it sprawled over 500 acres. This German Government building was constructed during the 1893 Fair and was left to serve as a park refectory and restaurant (1909).

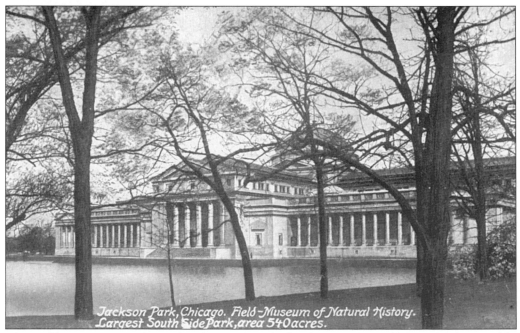

Jackson Park, Chicago. Field-Museum of Natural History. Largest South Side Park, area 540 acres.

The Field Museum was located at the north end of Jackson Park. At the time of the World's Fair of 1893, it was called the Fine Arts Building. It was one of only five buildings left from the fair in 1900. It still has in its collection some of the artifacts from the Fair.

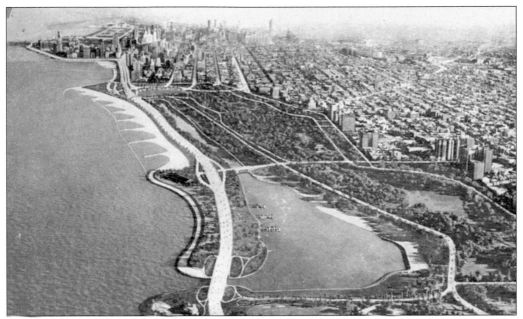

This aerial view of Lincoln Park illustrates just how large the park really is. Information on the card stated, "Showing expressway through the Park and the Underpasses. Sidewalks and a passage way provide pedestrians safe access to Park facilities." The view only shows part of the 600-acre park.

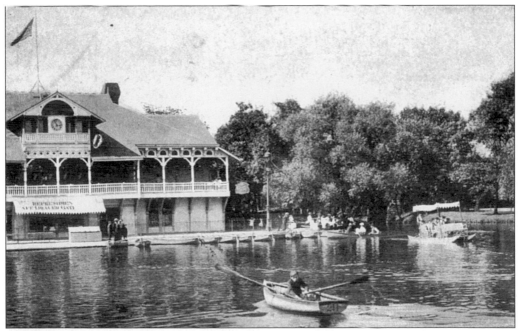

Graceful bridges are found in Lincoln Park as well as a wide, tree-lined, half-mile Mall. The above postcard shows the popular refectory building and boathouse. Lincoln Park is only 2 miles from the city center. In 1886, the district began the process of building a sea wall to add to the breakwater installations (1908).

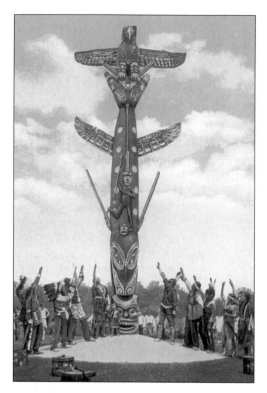

No, this is not a postcard from Alaska but from Lincoln Park! Full-blooded Native Americans are shown here at the dedication ceremony of the *Kwa Ma Rolas* totem pole at the Addison Street entrance to the park. It was carved out of a yellow cedar tree over 100 years old (*c.* 1930).

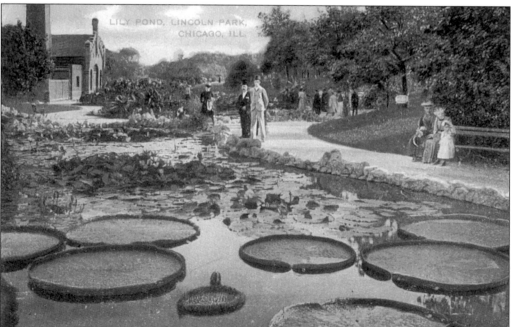

Lincoln Park officials were proud of their seven different kinds of night-blooming water lilies. They began to open at about six at night and stayed open until six in the morning. The flowers appeared on stalks about 12 inches above the water. In one season, a single plant would cover a circle 20 feet across with flowers a foot high.

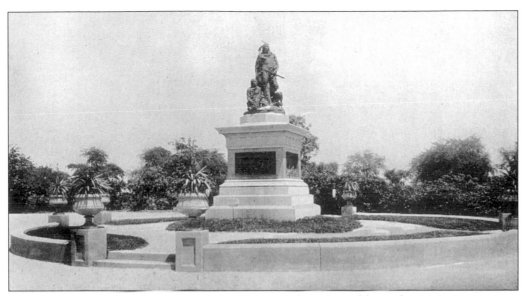

Lincoln Park has a fine monument to the Ottawa Indians created by sculptor Martin Ryerson. Called *The Alarm*, it features a Native American with his wife, child, and dog on the alert as if watching a stranger or an event far in the distance. Ryerson called these people "my early friends."

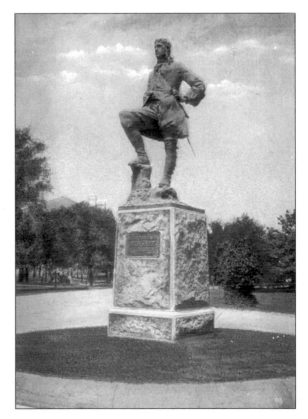

In the late 1880s, a life-sized statue of Robert LaSalle, the great French explorer, was added to the hardscape of Lincoln Park. It was donated by Hon. Lambert Tree and designed by De La Laing, a noted Belgian sculptor (1908).

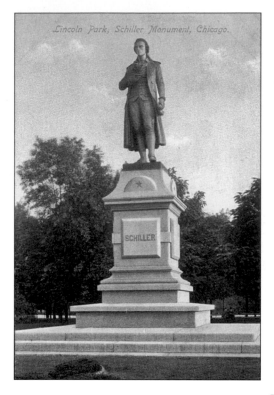

This Schiller statue was completed in 1886, and donated to Lincoln Park by German-American citizens of Chicago. The 10-foot statue is a copy of the statue in Marbach, Germany, sculpted by Dannecker. A later monument to Goethe was designed along Greek lines with the writer holding an eagle.

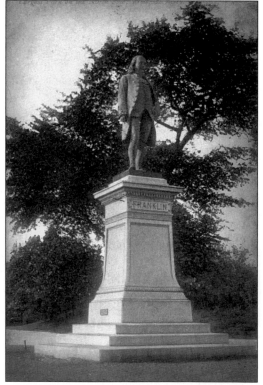

Benjamin Franklin is memorialized in Lincoln Park as this postcard shows. Franklin was one of the key figures in the colonial period prior to our country's independence. He arranged for critically needed French arms, supplies, and troops during the War for Independence. In addition to being a patriot, he was a well-known wit, author, and shrewd businessman.

Douglas Park had 179 acres. Chicago's major parks were designed to be connected to each other by wide boulevards. Garfield Park connected to Douglas Park by Douglas Boulevard, all part of a chain of three drives linking the parks of the West Side. In 1890, a large Palm House was constructed and named the Wintergarden (1909).

Also on the grounds of Douglas Park was a lake, lily pond, green houses, bandstands, and a refectory. Like other parks, it had its own artisan well. The park was named after Stephen A. Douglas, United States Senator from Illinois, who was often Lincoln's debating opponent over issues regarding slavery and expansionism. The monument to Douglas is shown here.

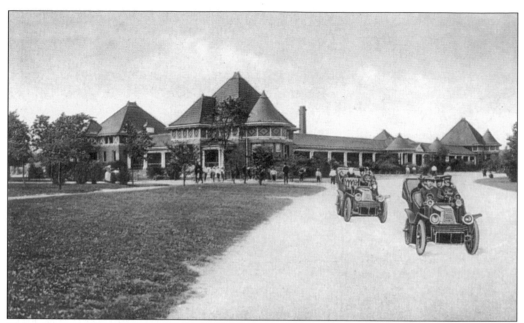

This view is of the huge natatorium (indoor swimming pool) at Douglas Park. This park also had an artesian well from which thousands of gallons of this water were carried away in jugs to private homes in the surrounding districts each year. One of the most popular natatoriums was called Kadish's, located at Jackson and Michigan.

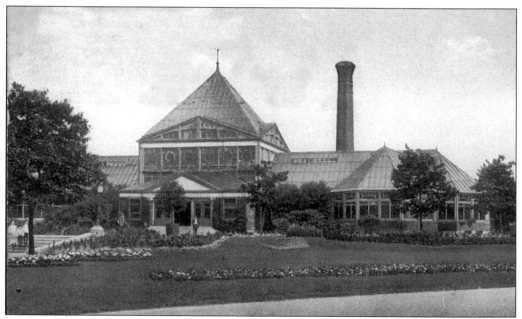

It is a shame that the original conservatory buildings in the Chicago parks were not saved for posterity. As they became too small to house the park's expanding collection, the Palm Houses and Conservatories were torn down and replaced with larger, but less beautiful new buildings.

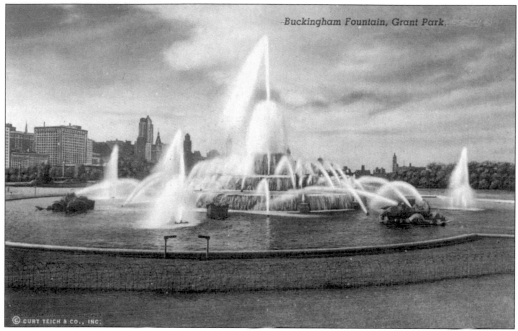

Buckingham Fountain, Grant Park.

© CURT TEICH & CO., INC.

Grant Park has monumental attractions. Its crown jewel is Buckingham Fountain, a copycat of the Latona Fountain in Versailles, only Texas-sized. The water is sent through 133 fountains and can throw a spray 135 feet into the air. General Electric built it, and Kate Buckingham paid the $700,000 bill.

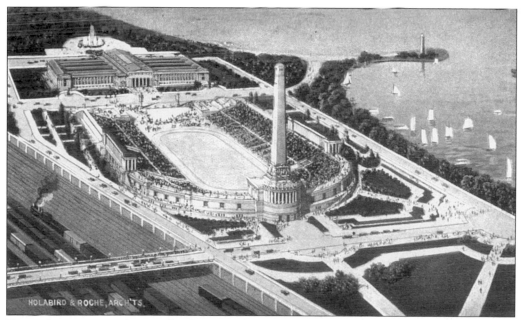

HOLABIRD & ROCHE, ARCH'TS.

Excavations were underway for Grant Park in 1901. It was named after General, and later President, U.S. Grant. Congress and Monroe were cut into the park and extended to Columbus Drive to handle the increased traffic. Chicago's new stadium is shown here in a bird's-eye view. The stadium was the work of the architects Holabird and Roche (1926).

65

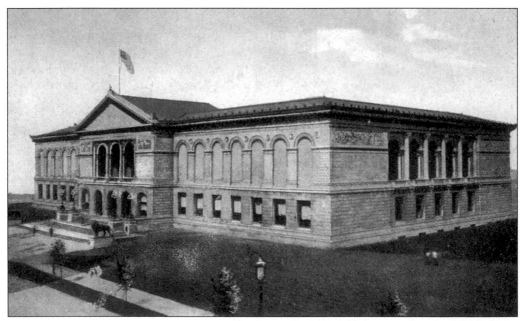

INTER-STATE INDUSTRIAL EXPOSITION OF CHICAGO.

Complimentary

Admit

John P. Reynolds Secretary. *Potter Palmer* President.

National Lithographic Inst. 5th Ave. & Washington St.

A gigantic Exposition Building, which was the McCormick Place of its day, was on the site of the present Art Institute. This ticket was for attending the Interstate Exposition of Chicago in 1873. Notice that it is a hand-signed pass given out by Potter Palmer!

Enough of this new home for the Art Institute of Chicago was complete in time for the World's Fair of 1893. The founders of the Institute, like Charles L. Hutchinson, wanted to not only exhibit great art but also to actively engage in the teaching of art. Other founding fathers were Ryerson, Ayer, Glessner, and Spraque.

Spirit of the Lakes is the work of Lorado Taft and was first installed on the south wall of the Art Institute. It was moved when additions were added to the new west-facing wall. Five maidens are part of the work, each representing one of the Great Lakes. Each maiden has a basin, and water flows from each basin down to a larger basin. This is one of Taft's finest works.

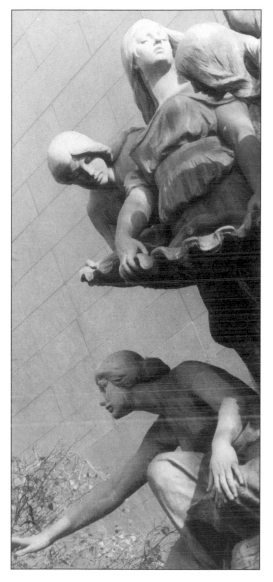

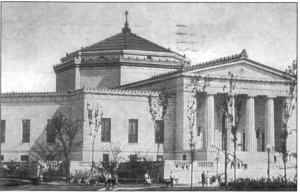

The John G. Shedd Aquarium in Grant Park was constructed of Georgian marble. The building was constructed in 1929, and was designed to fit with other buildings in the park which were of the Doric/Ionic Greek temple types. It is located at the south end of Chicago Harbor. Shedd spent $3,000,000 to complete this building.

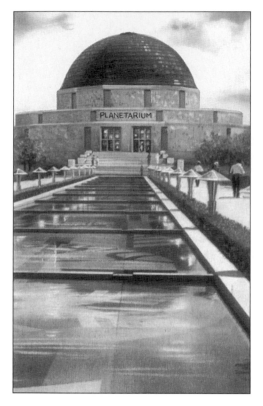

Sears, Roebuck & Co. executive, Max Adler, provided the funds to construct this observatory in 1939. It is a Romanesque building with Art Deco dressing. When constructed, it contained a $90,000 Zeiss projector, which was used to reflect the planets and stars on the underside of the building's vaulted dome.

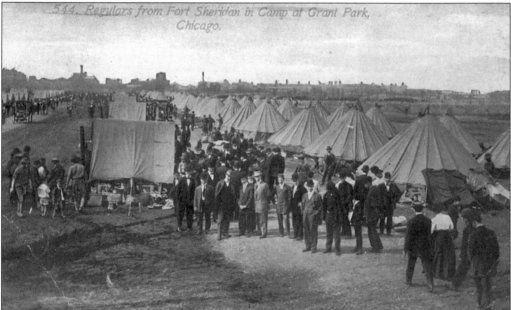

Before the lakefront was cleaned up, due to pressures from the likes of Montgomery Ward, all kinds of uses were made of the land such as expositions, cemeteries, and military encampments. Shown in this view are regular soldiers from Fort Sheridan outside their tents on the green of Grant Park. The use of the park for military activities continued for years (1911).

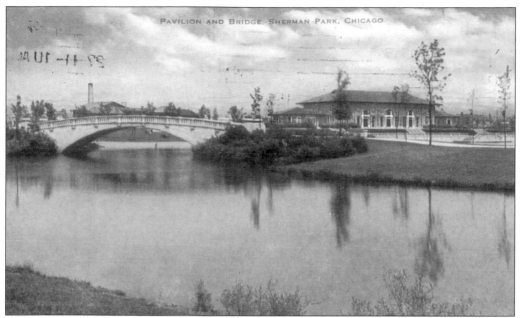

Sherman Park was one of Chicago's many "Play Parks." It had vine-covered pergolas and a pavilion reached by an impressive stone bridge as shown on this postcard. These smaller parks were built on lesser acres as the big parks but were more convenient for many Chicagoans to enjoy (1911).

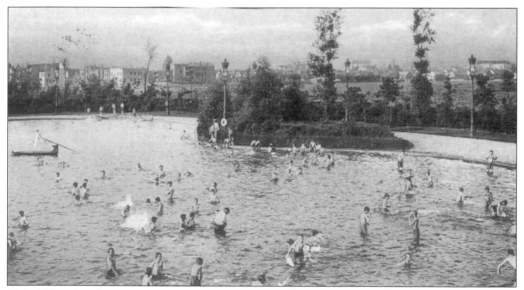

This 1906 view features another of the parks, which were in what the city called "The Small Park System." McKinley Park featured swimming and wading pools, which allowed children to escape the hot summer streets. Note the lifeguard on a boat to the left.

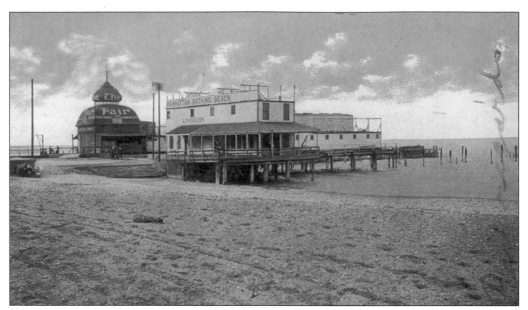

Changing rooms and refreshment stands were beginning to be offered at the bathing beach parks for bathers. This postcard view is of Windsor Park located on the South Side. The building to the left was called The Fair, and was probably run by the downtown mega department store. The other building is called "The Manhattan Bathing Beach."

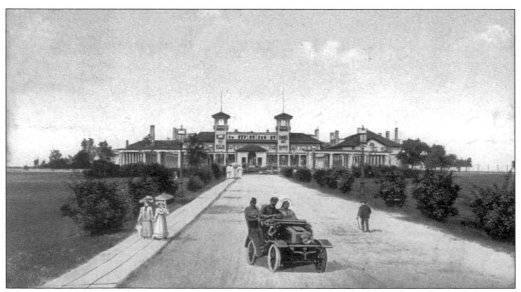

The South Shore was also the site for a country club. It was located on the lakeshore from 67th to 71st Streets on South Shore Drive. Notice the wide roadway and what appears to be a wooden planked sidewalk on the left. The building had columns on all sides.

Four
STREETS, SHIPS, AND TRAINS

*R*udyard Kipling visited Chicago in 1914, and he later wrote that it was a "boss" town, full of people who were barbarians and were always "taking about money and spitting everywhere." His witty comments about Chicago being a town of fast times and fast fortunes was an accurate view of what drove the city's phenomenal growth. While Kipling saw danger and decay in such a frenzied lifestyle, Carl Sandburg writing in that same year saw freshness, virility, and greatness. His poem about Chicago told of the city as a center of tool making, hog butchering, and railroading. He ended his work with one of the best descriptions ever coined about the city, "Stormy, husky, brawling. City of the Big Shoulders."

In its Opulent Age, Chicago was the hub of a vast railroad network which transported farm goods and raw materials into the nation's cities and shipped finished goods to meet the demands of the entire country. Two Goliaths of the mail order business, Montgomery Ward and Sears Roebuck, put down their roots in Chicago.

In order to keep trade flowing out of the city's businesses, Chicago had to have efficient ways to move workers and commodities within the city. City traffic became so congested that the city introduced cable cars on State Street in 1882, and an elevated railway system at the end of the nineteenth century. This proved necessary not only to get workers in and out of the city's factories and stores but also to transport customers into the city to shop the famous mega retail stores. Into the city's railroad stations came visitors from the dozens of towns that had developed west, north, and south of the city, all anxious to shop the famous stores such as Marshall Field and the Boston Store.

Chicago's piers on Lake Michigan and the Chicago River were used to facilitate transportation and shipping. The airplane made its formal debut in Chicago in 1911, and few would envision that this new mode of transportation would make the city one of the greatest hubs of air transportation.

This postcard shows one of Burlington Railroad's sleek and fast diesel-driven trains, which was called the Nebraska Zephyr. This stainless steel train made daily trips between Chicago, Omaha, and Lincoln. Accommodations included a parlor car with observation lounge, dining car, three coaches, a dinette coach, and a cocktail lounge.

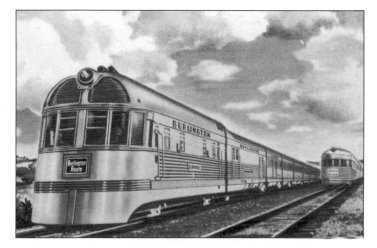

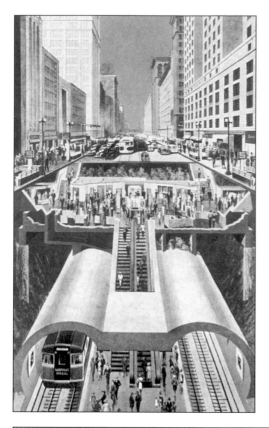

In 1899, Chicago built a 60-mile subway system under the major streets. The system was used to transfer coal, ashes, and freight. Also in the tunnel was a pneumatic tube to transfer documents between banks and other businesses. Later, as shown on this postcard, the city did construct a short subway system for passengers complete with mezzanines and escalators on State Street.

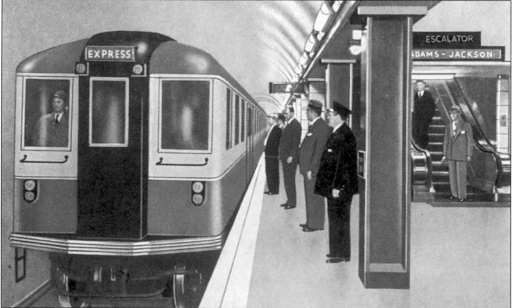

This view shows the platform level of the system with an express train stopping at the Adams-Jackson entrance. The entire system had eight mezzanine stations, each located in the middle of a block. There are four entrances connecting each mezzanine with the sidewalk above.

Chicago's elevated electric "L" railroad is shown here at Wabash looking north from Van Buren. All along the "L" were stations that hung off the side of the tracks, with staircases leading to street level. These birdhouse-like stations were designed by famous architects, many in high Victoria style.

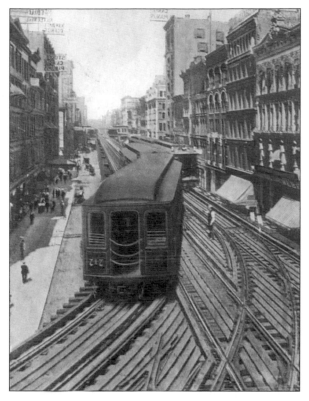

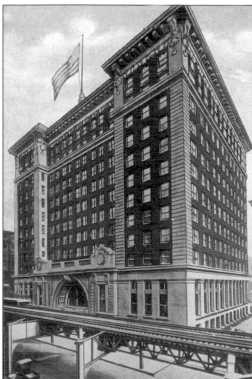

Charles Tyson Yerkes, railroad genius and ex-convict, designed the "L," and the city's Union Loop was completed in 1897. By 1910, an expanded system was transporting a quarter of a million people each year. Shown behind the "L" tracks is the LaSalle Street Station, designed by Frost and Granger in 1903. It was demolished in 1981, to make room for the Midwest Stock Exchange (1908).

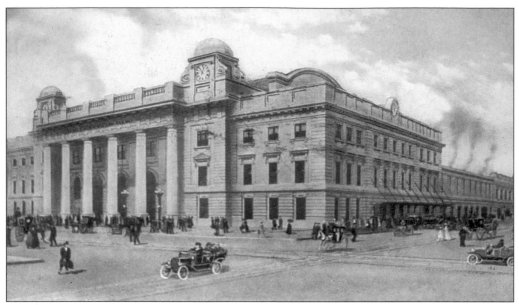

Another classic Chicago railroad station was the Chicago and Northwestern Station at 500 West Madison, facing Madison, Canal, Washington, and Clinton Streets. It was the only Chicago station servicing a single railroad line. Designed by Frost and Granger and opened in 1911, it was the largest station in Chicago. It had a three-story waiting room topped with an elliptical, barrel-vaulted, tiled ceiling and walls of marble trimmed in bronze.

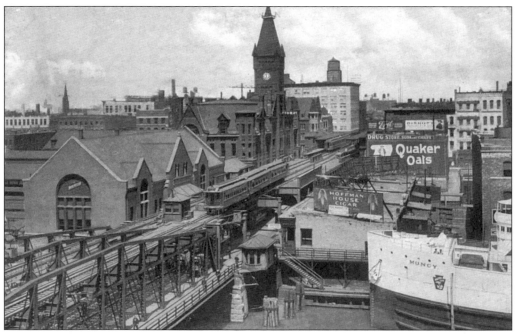

The Rush Street Bridge, completed in 1856, was the first to be built over the Chicago River. The Halsted Street Bridge was the first vertical lift bridge which moved up and down like an elevator. It opened in 1894. Shown above is the Wells Street Bridge, with the Northwestern Station in the background. Note the extensive use of billboard advertisement on this busy street (1909).

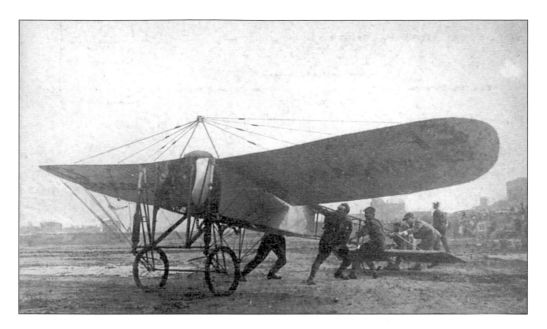

Early aviation was encouraged by newspapers who sponsored long distance flying contests. In 1911, the *Chicago American* put up $50,000 as prize money for any "flying machine" that could fly coast to coast in a set time. Armour & Company had a soft drink at the time that they were promoting called Vin Fiz, so a "Vin Fiz" plane was entered in the race. Its pilot, Cal Rodgers, won the race, traveling the distance of 4,230 miles in 39 days. He was only in the air for three days and ten hours of that time.

In that same year, Harold McCormick sponsored the first International Air Show in Chicago. Planes were paid $2 for every minute that they remained airborne. Some pilots collected as much as $8 or $9.

The above place is a French Bleriot monoplane. Its first version flew in 1897, and a later model was the first airplane to be used in a war. Below is a Curtiss Hydro-Biplane, which was also at the Chicago meet. This single engine pusher place was sold as the Model F-Boat and bought by the United States Army and Navy in 1912.

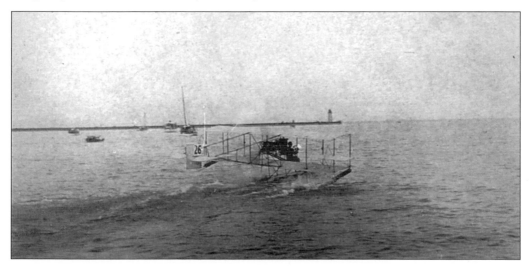

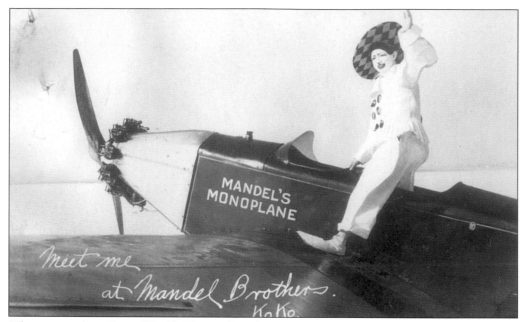

Pilots returning from World War I bought inexpensive surplus planes and went out barnstorming. They appeared at county fairs and entered races. Planes old and new were used to advertise in the air by pulling huge banners. Shown on this card is the famous clown KoKo with the Mandel Brother's Circus monoplane encouraging people to visit him at the big top.

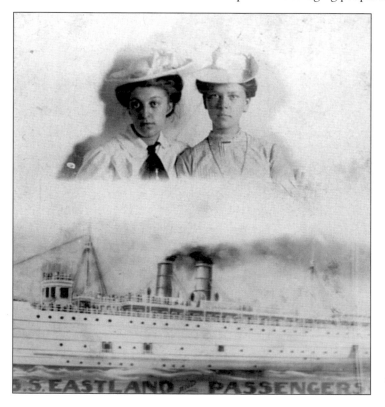

This card shows two young ladies who traveled on the steamship *Eastland* in 1907. The ship stood at dockside on the morning of July 24, 1915, ready for a Lake Michigan cruise. The dockside decks were crowded. Suddenly, the ship rolled over, trapping passengers below the water line. Of the 2,500 people on board, 835 died. Nearby passengers on the *Roosevelt* looked on in horror.

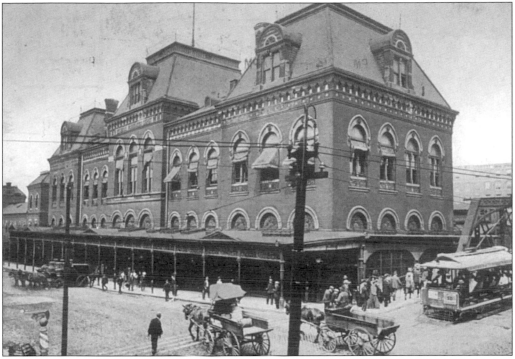

W.W. Boyington designed the first Union Station, which was built in 1881. The railroad station, called the headhouse, was built beside the tracks instead of in front of the tracks. This two-story station was in the neo-Gothic manner with three large Mansard roofs. It was demolished in 1925, to make way for the tracks entering the new Union Station (1913).

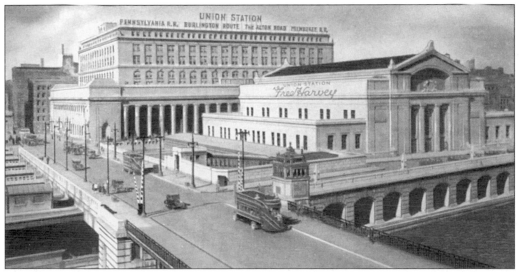

The new Union Station serviced six railroad lines in the 1940s, and was the largest interior space constructed for a Chicago station. It is often compared to New York City's Pennsylvania Station, which was built in 1910. The station was made with two buildings, the building shown here has Tuscan colonnades of Indiana limestone. Construction was begin in 1914 and completed in 1925.

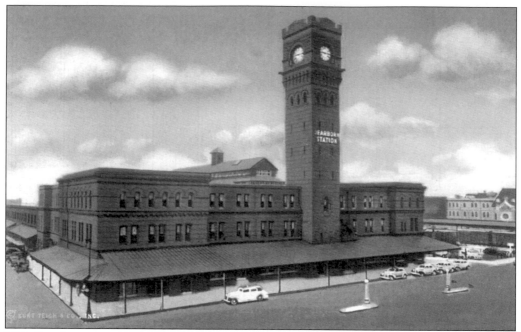

This Dearborn Street Station was drastically altered after a fire in 1922. But in 1885, when it was designed by Cyrus Eidlitz and built, it was an elaborate Dutch Renaissance styled building with a fancy clock tower, topped with an ornate weather vane. It was constructed of brick, terra cotta, and brownstone and had an iron framed shed for trains.

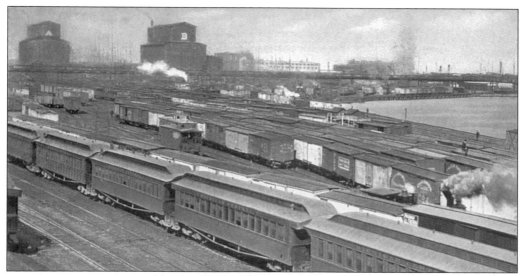

Soon the city began to grown up to and surround the various railroad yards, which were at one time outside the city proper. In the early years of the Opulent Age, these yards were critical to the growth of the city and transportation. Later, they were to hamper an expanding city. This postcard shows the Illinois Central & Michigan Central rail yards.

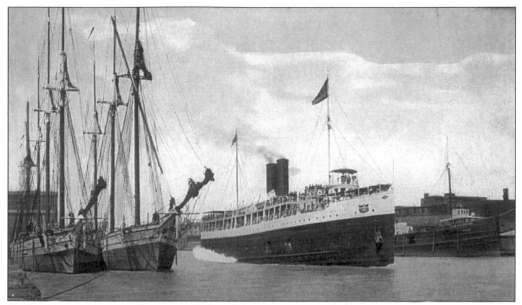

Eastland was refitted and renamed the *Wilmette,* to be used as a naval trainer vessel. She is shown here under steam passing some anchored wooden ships. An earlier disaster occurred on the lake in 1889, when the side-wheeler *Alpena* sailed out to cross the lake. Caught in a squall, the ship and its 70 to 80 passengers were never found.

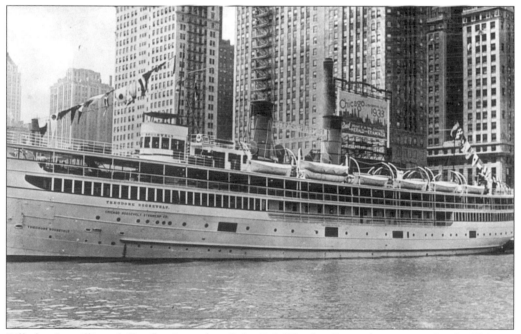

Billed as "a million-dollar floating palace," the *S.S. Theodore Roosevelt* was operating in Chicago at the time of the Century of Progress Fair in 1933. It offered direct service form Michigan to Chicago. Benton Harbor, Michigan, was one of the ports from which travelers could take a four-hour shoreline cruise for 75¢. The vessel was used until World War II.

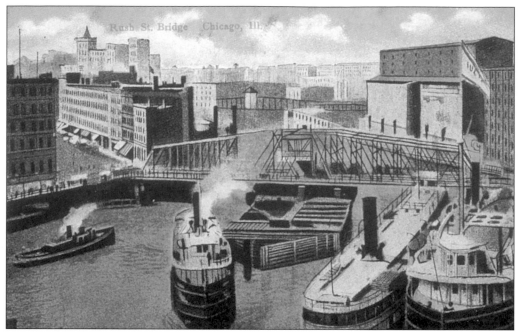

Commercial traffic on the Chicago River was heavy during these years. Shown here is the riverfront at the Rush Street Bridge, which pivoted in the center. Chicago began to clean the river in 1902. At that time, Chicago was the fourth busiest port in the world just behind London, New York, and Hamburg. Once cleaned up, it was called Chicago's "Cinderella" transformation (1909).

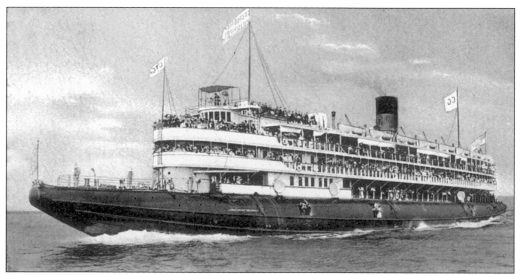

The *S.S. Christopher Columbus* was the only whaleback vessel built to carry passengers. Usually these vessels transported grain on the Great Lakes. This ship was completed in time to see use during the 1893 Columbian World's Fair. In its 40-year career, it carried two million passengers. One whaleback was named after its inventor, Alexander McDougall, and that ship was the only one to have a blunt nose (1904)!

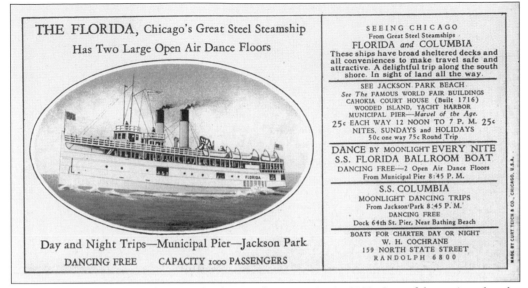

Another famous steamer, the *S.S. Florida*, was also in service in 1893. One of the cruises that the steamship company offered on the *Florida* and its sister ship, the *Columbia*, set out from the old municipal pier to take passengers to see the World Fair buildings, Cahokia Court House, Wooded Island, and the yacht harbor. During the week, round trips could be made for 50¢.

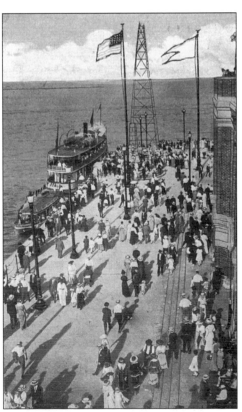

Here is a view from the Observation Tower of the new Municipal Pier, which was built in 1915 and 1916. It was located at the foot of Grand Avenue and was a three-story structure extending 3,000 feet into Lake Michigan. The top floor was used as a promenade, as were the walkways on either side of the building. Excursion steamers left from here to various points on Lake Michigan.

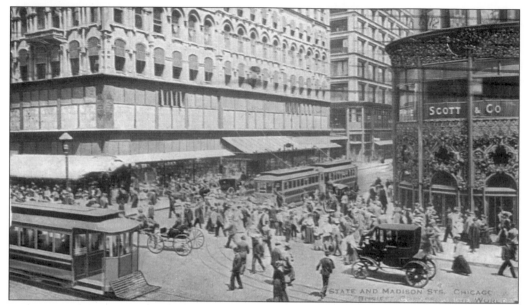

Four modes of travel along Chicago streets are shown in this postcard, featuring the corner of State and Madison Streets. Called the "busiest corner in the world," people traveled on foot, in horse-drawn carriages, overhead electric trolleys, or electric cars, which were the latest rage. The store to the right is the Carson, Pirie, Scott Department Store. The building is noted for the Art Nouveau grillwork designed by Louis Sullivan.

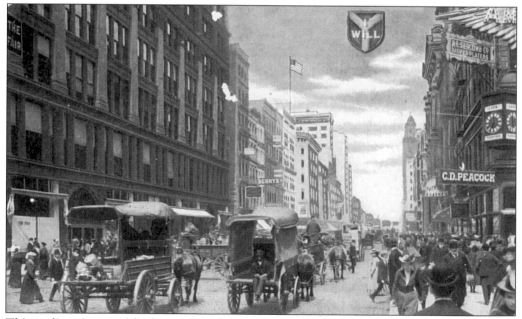

This earlier view card looking north from Adams on State Street shows the sign for C.D. Peacock Company, jewelers, to the right. Peacock came to Chicago in 1837, and was selling watches and clocks in the city before it even had a charter. Located at 101 South State, it was billed as the city's oldest store. The "I Will" slogan for Chicago's spirit was coined in 1843, by the editor of a city direction and used far into the next century.

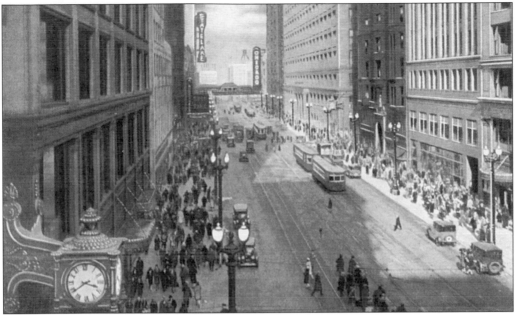

This later view of State Street looks north. To the left is the famous Marshall Field clock, and the street is clear of wagons and horses. Trolleys and cars rule Chicago's downtown streets by this time. Notice the new street lighting and the electric marquee signs in front of theaters.

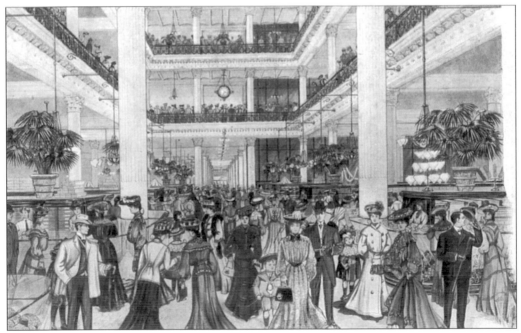

There was nothing like Marshall Field's store on Michigan Avenue. During the Opulent Age, it was one of the world's most famous "palaces" of retailing. This advertising postcard shows a view of the main aisle on the first floor, which was nearly 400 feet long. Decorated to the nines, plants and clocks all worked with massive colonnades to make shopping a unique and exciting experience (1904).

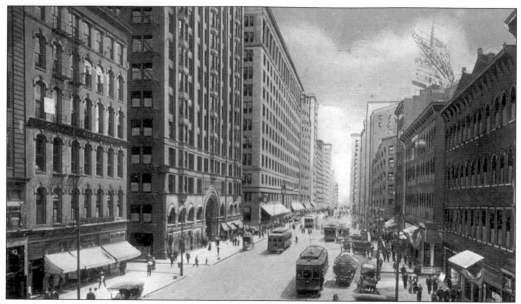

Our last look at State Street is a view taken south of Lake Street. On the right side, look to the top of the building to see a huge sign advertising Edelweiss Beer brewed by the Peter Schoenhofen Company, whose slogan was "a case of good judgment." It was a golden beer with a curvy bottle that had a green label with a red banner across the neck.

The 1871 Chicago Fire destroyed the Chicago Library Association's building and its 30,000 volumes. Money and books poured in from all over the world for a new library. By 1872, the temporary library on the fourth floor of city hall had almost 172,000 books! In 1897, the books were taken to their new home on Michigan Avenue, shown in the card. This Chicago Library building was designed by Shepley, Rutan, and Coolidge (1906).

Five
CULTURE COMES TO TOWN

*T*heodore Thomas was the first "Grand Old Man of Music" in Chicago. With the installation of Thomas as head of a permanent orchestra in 1891, Chicago's arts scene took a giant leap forward and has never since caught its breath. Possessing world-class concert and opera halls by the 1890s meant that all the legendary musicians would come to Chicago. And across the street from all this music making on Michigan Avenue, the newly formed Art Institute of Chicago would also become a major player in the culture of the city. Driving all this energy and popularity of the arts were all of the emerging middle- and upper-class women and men who were free to explore what culture had to offer.

Chicago was being enriched by people from all over—Europeans, Asians, and migrating blacks from the Deep South—all seeking a better life. With these new immigrants not only came arms for industry but also a love of their culture and the need to express themselves in the arts. The Germans and Italians made sure that the city had a first-class orchestra and opera house. Chicago's Blacks brought with them the blues, born out of former slavery, and jazz, America's unique music. Blacks also made significant contributions to all of the other arts equal in importance to the Harlem Renaissance of the 1920s in New York.

The love of opera is deep in the blood of Chicago. The Chicago Grand Opera Company was championed by Mary Garden. The company's greatest moment was when it moved into the new Civic Opera House in 1929, but it barely survived the Great Depression. In 1956, Lyric Opera was born, which has become one of the great opera companies in the world, playing to 103 percent sold-out houses!

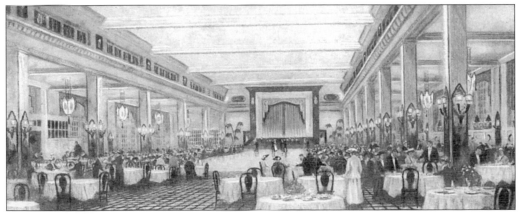

The arts go with the good life. They help create the need for fine hotels and ethnic restaurants. One could visit the Bismarck Garden on Broadway and Lake before the performances at Orchestra Hall or the opera. In the summer, the Marigold Room, with its expansive ballroom floor and stage was artificially cooled to 72 degrees. Notice the dancers on the floor and that the music is provided by an automated mechanical instrument.

"Now I am 53, too old to travel. . . New York can not support my orchestra alone," so said Theodore Thomas to Chicago businessman Charles Norman Fay in a corner table at New York's Delmonico restaurant one day in April of 1889. Fay replied, "Would you come to Chicago if we could give you a permanent orchestra?" Thomas flashed back, "I would go to hell if they gave me a permanent orchestra!"

Miraculously, only two years later, the orchestra was ready for its first performance. Thomas lifted his baton for the Chicago Symphony Orchestra for the first time on October 17, 1891, in the Auditorium. Thomas and his orchestra's contribution to the musical life of the city was acknowledged when the Thomas Monument was erected on the lakefront. Thomas as a Roman musical God is shown here against a wall carving of his beloved players in the Chicago Symphony.

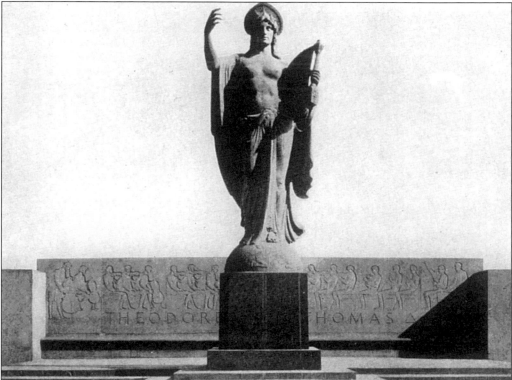

Patrons loved to hear their orchestra play in the lush setting of the Auditorium, never realizing that this was not a perfect setting for an orchestra. Thomas' dream of a smaller, new hall with a clean and warm sound was to become a reality during his 14th season. Thomas conducted the dedication concert in 1903. Sadly, Thomas caught a cold and influenza developed. He died on January 4, 1904. The memorial concert for Thomas included Wagner's *Siegfried's Death March* and Strauss' *Death and Transfiguration*.

Frederick Stock, who Thomas had made Assistant Conductor in 1899, was appointed the orchestra's new conductor. Stock would remain as conductor of the CSO until his death in 1942. He championed the music of Debussy, Ravel, Mahler, and Prokofiev. He pushed for a training orchestra for the CSO, and in 1919, the Chicago Civic Orchestra was created. Stock was adored by his players, who called him "Papa" Stock.

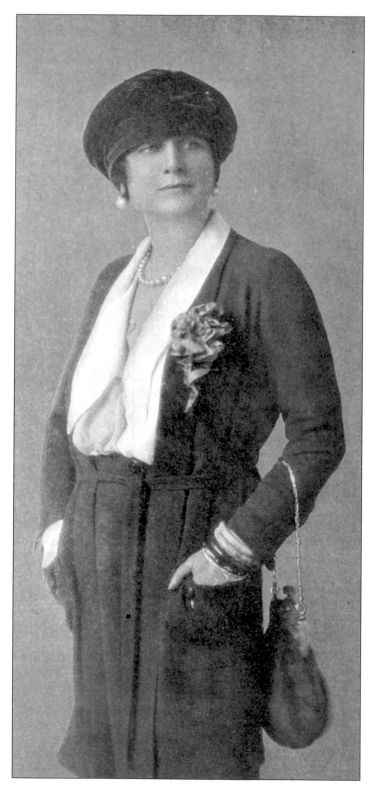

Mary Garden sang in the first year (1910) of the Chicago Grand Opera Company, appearing in *Pelleas et Melisande*. She brought to her roles not only singing ability but also dramatic impact and ballet-like movements. Huneker described her as, "A condor, an eagle, a peacock, a panther, a society dame. . . a siren. . . a superwoman."

Her second role that season was as Salome in Strauss' opera of the same name. The conductor Campanini had a large orchestra and 27 rehearsals to prepare this opera. For the role, Garden was corsetless and dressed in a gold mesh costume that only went down to her knees, draped on one side to suggest nudity for the dance of the seven veils. Conservative Chicagoans in the audience went into shock. After seeing the next performance, the police chief said, "Miss Garden wallowed around like a cat in a bed of catnip." Too hot for Chicago, the opera was canceled. Garden later performed *Salome* at the Chicago Grand Opera as well as an equally steamy opera called *Thais*. She became the director of the company, and in this capacity she received threatening letters, knives, and bullets through the mail.

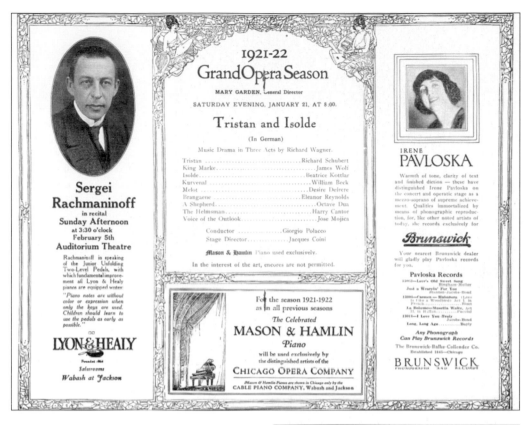

The opera company's 1921–22 season was one of those golden years for opera in Chicago. The finances of the company were in the hands of Harold F. McCormick, Charles Dawes, and Samuel Insull, with Garden acting as general director. The American premier of Rimsky-Korsakoff's *The Snow Maiden* was presented in that season, along with a fine production of Wagner's *Tristan and Isolde*. Rachmaninoff also appeared at the Auditorium that year. Before performances, one could have a "Table d'hôte Dinner" in the Auditorium Hotel restaurant for $1.50.

One of the stars of the Chicago Grand Opera Company was Irene Pavloska, shown in the view above and to the right. She recorded for Brunswick Records and was described as having "warmth of time, clarity of text, and finished diction." A mezzo-soprano, she sang the roles of Musetta in *La Boheme*, Siebel in *Faust*, and Charlotte in *Werther*. She also sang with Jornet as Mephistopheles in *Faust*.

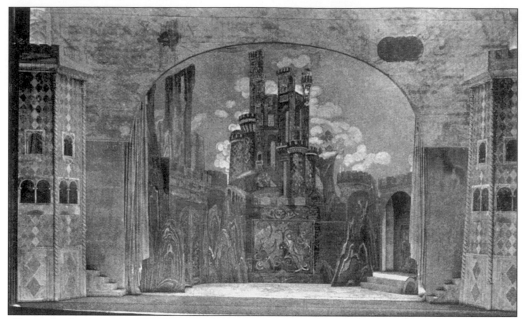

Chicago Daily News' Ben Hecht attended a rehearsal of the world premiere of Prokofieff's *The Love for Three Oranges,* which was written for and first performed by the Chicago Grand Opera Company in the 1921–22 season. Hecht, anything but a professional opera critic, declared the opera a "fantastic lollipop. . . to suck and rub in our hair." He liked it, but the critics and public found it out of reach. Chicago music critic Edward Moore of the *Tribune* snarled, ". . . I detected the beginnings of two tunes." Only two performances were given.

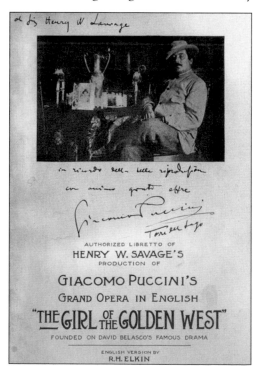

One new opera Chicago did like was Puccini's *The Golden Girl of the West*. Given in Chicago only 15 days after its premiere at the Metropolitan, Mary Garden was to have sung the leading role, but it went to Caroline White, a singer from Boston. Caruso created the role of Dick Johnson at the Met, and he even came to Chicago to sing in one performance of the work.

Cyrena Van Gordan sang Amneris to Rosa Raisa's Aida during the 1913–14 season of the Chicago Grand Opera. It was her first time to sing the role and the first year to sing with the company. She specialized in Wagnerian roles. In the 1919–1920 season, the production of Wagner's *Die Walkure* was retitled, shortened, and sung in English in order not to feed the flames of anti-German sentiments. Gordan portrayed the first Americanized Brunhilde! She was magnificent in the role as was her Wotan, Georges Baklanoff. After the war and during the Depression, it was Wagnerian operas that helped keep both the Chicago Grand Opera Company and Metropolitan Opera solvent. From Caruso to female opera stars such as Gordan, there were plenty of opera singers in need of width reduction, ideal candidates for corset advertisements.

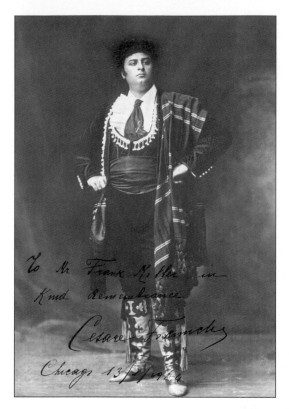

For 10 years, Cesare Formichi was the mainstay baritone of the Chicago Grand Opera Company. He made his debut at Convent Garden in 1924. Among the roles he was famous for in Chicago were Amonastro in *Aida,* Don Carlo in *La Forza del Destino*, Rigoletto in *Rigoletto*, and Iago in *Otello*. His was dubbed "the biggest voice in the world" (1924).

Giacomo Rimini was the husband of Rosa Raisa and sang with her in many of her Chicago performances. In 1924, when Toscanini selected Raisa to sing the role of Turandot in Puccini's *Turandot*, Rimini was chosen to sing the role of Ping. A Chicago critic said that his singing had a "unique richness and hugeness of tone. . . staked out vocal proportions quite beyond the capacity of any singer known in our generation."

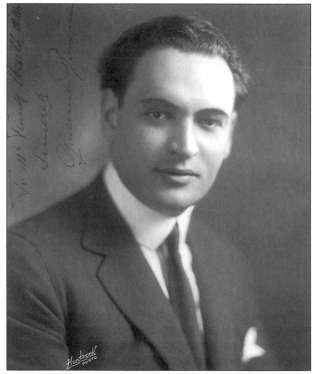

92

Giorgio Polacco made his conducting debut at the Metropolitan Opera in 1917, replacing Arturo Toscanini. The next year, he started conducting at the Chicago Grand Opera. Starting in 1922 until 1930, he was the company's principal conductor. He was a stickler for musical details and the leading conductor of French operas during the Mary Garden years.

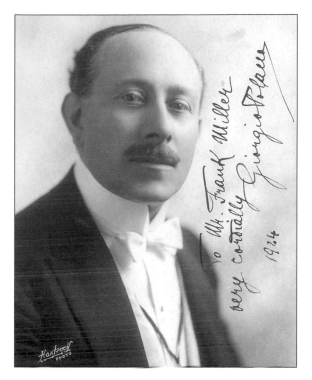

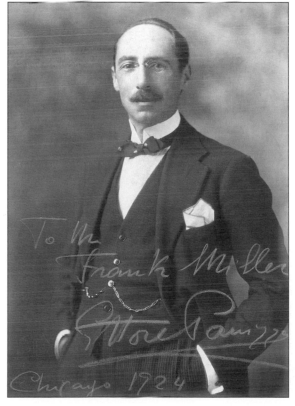

Ettore Panizza was but one of the many conductors for the Chicago Grand Opera whose last name started with a "P." In the company's first season, Maestro Parelli conducted an *Il Trovatore* and Maestro Perosio a *La Boheme*. Egon Pollak conducted a *Ring Cycle* in the 1915–16 season, and Polacco was famous for crafting a fine *Romeo and Juliet* in the same year Panizza conducted a *Carmen*.

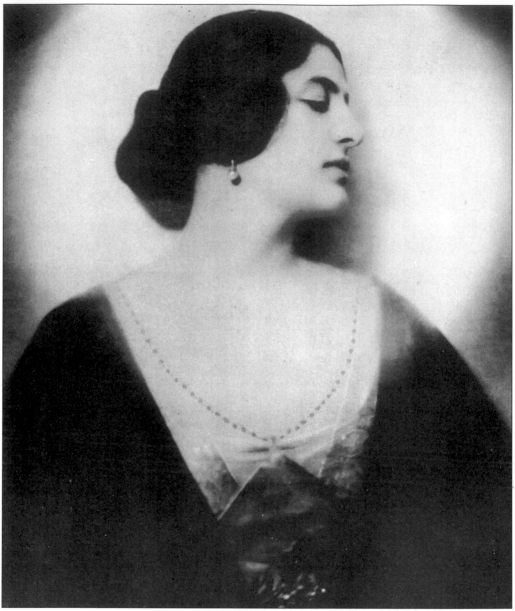

Rosa Raisa was born in Poland in 1893, and later escaped a pogrom. She started her singing career in Italy in 1913, and in that same year sang the role of Isabella in *Cristoforo Colombo* in Philadelphia and at the Chicago Grand Opera. Her early roles in Chicago were as Aida and Mimi. Until 1937, she was a mainstay of the Chicago Grand Opera. She ended her career singing Santuza in *Cavalleria Rusticana*. Raisa premiered many Mascagni operas at various opera houses. She appeared as most of the great heroines of opera—Mistress Ford, Minnie, Maliella, Leonora, Norma, Madeleine, Aida, Mimi, Desdemona, Rosalinde, and even as Cio-Cio-San.

Critics said she was as dramatic in her roles as Mary Garden. She had a powerful voice, which at times upset critics. She responded to their snipes by saying, "You should have heard me in South America, where they really like loud singers!"

George Baklanov (ff) was a baritone from Latvia. Baklanov sang the first Baron in Rachmaninoff's *The Miserly Knight*. He joined the Chicago Grand Opera Company in 1917, and continued there until 1926. Baklanov appeared in such roles as Mephistopheles, Scarpia, and Rigoletto in Chicago. He was said to have had a colorful voice, best in the middle and upper ranges (1924).

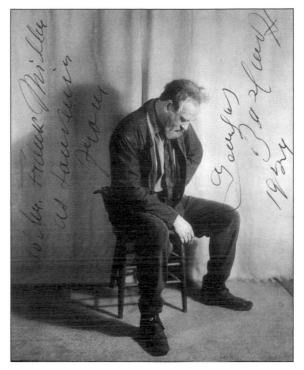

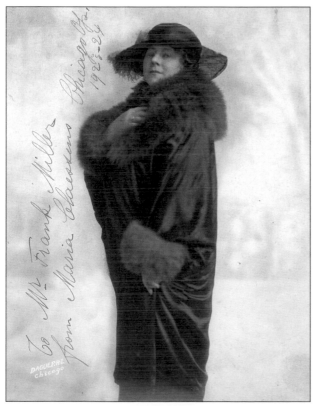

Maria Chaessens joined the opera company in their 1917–18 season, singing the title role in *Aida* and sang her last season in 1931–32. Claessens appeared as the nurse in *Boris Godunov*, Martha in *Faust* and *Mefistofele*, the witch in *Hansel and Gretel*, Emilia in *Otello*, Bertha in *The Barber of Seville*, the mother in *Louise*, and Teresa in *La Sonnambula* in the 1923–24 season.

Virgilio Lazzari was an Italian singer who debuted in Rome in 1914. Three years later, he was singing in Boston, and in the following year with the Chicago Grand Opera. Lazzari mastered 200 roles and continued to sing until 1951! His most famous role was that of Archibaldo in Italo Montemezzi's *L'Amore dei Tre Re,* which he sang with Garden in 1920. Lazzari was described as a good singer/actor with a competent voice (1927).

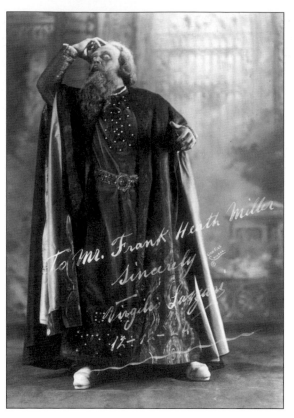

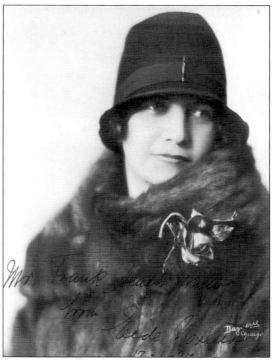

Eide Norene was born in Oslo in 1884, and began her career in 1907. She sang at the Stockholm Royal Opera House, La Scala, Covent Garden, London Opera, Paris Opera, Metropolitan Opera, and the Chicago Grand Opera. One of her Chicago roles was as Norena in the 1927 production of *I Pagliacci*. She was said to have had impeccable taste in molding her roles (1927).

During the 1934–35 season, the company had the best Tristan in the world, Lauritz Melchoir, singing in *Tristan and Isolde*, on loan from the Met. The company's *Lohengrin* sparkled with Jeritza as Elsa and the legendary Lotte Lehmann singing Elizabeth from *Tannhauser*. Wagnerian opera was saving opera companies in the United States in the 1930s, while in Germany it served as inspirational material for Hitler. There was no 1932–33 season.

Here is a picture of the yet-to-be completed Chicago Civic Opera House on Wacker Drive at Madison. The view was taken from the river and shows the rear view of the house with 35 stories of the soon-to-be 42-story tower. The structure was the brainchild of Chicago's energy czar Samuel Insull, and the rear of the building was said to resemble his throne. The opera's opening season coincided with the stock market crash.

97

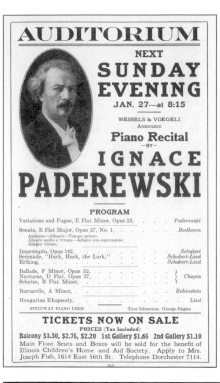

Most of the world's great pianists played Chicago, but none was more of a traffic stopper than Ignace Paderewski. The fiery redhead played at the World's Fair in 1893, causing women to swoon and faint at his concert. He had his own railroad car for travel in the United States. Paderewski played only Steinway pianos, which was not the official piano of the fair. Theodore Thomas smuggled him and his piano on stage behind the backs of fair officials!

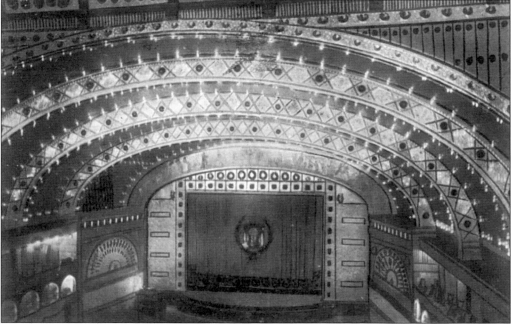

The immense 4,000-seat Auditorium Theatre is a marvel of engineering. Adler added an internal steel skeleton to support trusses over the theater, kitchen, and banquet hall. The space was so designed that the stage could be lowered. Grand balls were held for as many as 8,000 dancers. The thousands of clear bulb lights and ornate wall and ceiling treatments make this one of the greatest preserved theaters of the Gilded Age in America (1908).

The Castle Square Opera Company performed operas and operettas in the Fine Arts Building's Studebaker Theatre in 1889. The company excelled in Gilbert and Sullivan's *The Pirates of Penzance* during their 1901 season, with Francis Boyce in the role of the sergeant of police. Box seats for six could be had during that season for $2 to $6. Also in 1901, you could have a telephone installed in your home for 15¢ per day.

The Studebaker

The Fine Arts Building, Michigan Blvd., Bet. Van Buren and Congress Sts.

COMMENCING SUNDAY NIGHT. FEBRUARY 19th, 1911

HENRY B. HARRIS PRESENTS

RUTH ST. DENIS
IN A REPERTOIRE OF EGYPTIAN AND HINDU DANCES.
(Music by Walter Meyrowitz.)

PROGRAM.
ACT I.

THE FEAST OF ETERNITY.

Scene—In a banquet hall in the Palace of Pharaoh.
Dance—"The Tamboura."

During the earlier dynasties it was the custom of the aristocracy to give memorial banquets, called "Feasts of Eternity." At these gatherings, in the very height of the festivities, the Osirian mummy was introduced to remind them that this life is only transitory, and that real life is attained in the future world. The entertainment preceding the feast included the offering of wine, the interchanging of gifts, music, and then the dance.

ACT II.

THE VEIL OF ISIS.

Scene 1—The Outer Court of the Temple of Isis.

When the King visited the Goddess in her Temple he was met in the outer Court by the High Priest and the bearers of the Sacred Cow, which is a Symbol of Isis, and then they proceeded to the Holy of Holies.

Scene 2—The Sanctuary of the Temple.
Dance—The Manifestations of Neith, Hathor and Isis.

She is seen first as the Veiled One, knowing the Past, Present and Future; then as Hathor, goddess of Love and Music; and lastly as Isis lamenting Osiris, but finally triumphant over the evil power of Set.

ACT III.

THE FESTIVAL OF RA.

Scene 1—The Sacred Plains of Ra.
Dance—"The Dance of Day," typifying the rise and fall of Egypt.

To the mind of the ancient Egyptian the life of man as well as that of nations was symbolized by the course of the sun, which rose in the morning, reached the zenith at noon, and sank in the west at night. The different hours are illustrated by the types which represent the history of the nation from the primitive spear men to the height of conquest, then its decline, defeat and final death. Like the sun, which fought its supposed enemies in the underworld during the night and rose triumphant, so the soul of man, after death, was compelled to undergo a journey, or evening at the Judgment Hall of Osiris.

While Mary Garden kept opera goers in shock with controversial roles, the dancer Ruth St. Denis was giving audiences at the Studebaker her version of sophisticated hoochy-coochy dance. St. Denis was inspired by Egyptian and Hindu dances and freed American dancers from the classical ballet's restrictive movements. In this performance at the Studebaker, she played both the snake charmer and the snake! Later, she made dance history with her partner, Ted Shawn (see page 87) (1911).

The Opera

No. 1. CHICAGO, MARCH 2, 1898. Published by C. A. Ellis.

Walter Damrosch and his New York Symphony Orchestra played the Auditorium in 1898. His father had been the first to present German operas in New York. Damrosch's company presented 12 performances in Chicago that year from a repertoire of 24 operas, of which one-third were works of Richard Wagner. Divas Melba and Nordica traveled with his company of singers (1898).

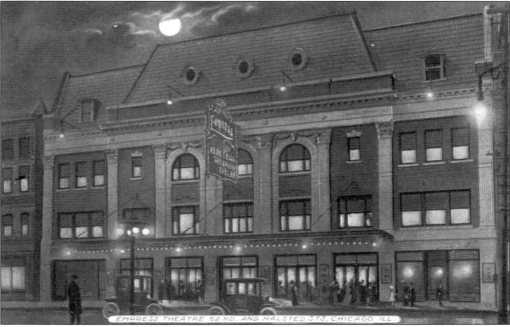

During this time, the city had over a dozen theaters presenting everything from sophisticated music, dance, and drama to vaudeville acts and movies. One of the nicest theaters in Chicago was the Empress, located at the corner of 62nd and Halsted. A lighted entrance and marquee of this beautiful coloumned facade added to the excitement of the evening.

The students of The Art Institute of Chicago gave their 13th annual Mardi Gras ball on Monday evening, February 11, 1925, at the Trinon. It was titled "Black Sea Ball, A Slavonic Enchantment." A pantomime opera called *The Eve of Ivan Kupal*, which poked fun at Russian operas, was performed.

BLACK·SEA·BALL

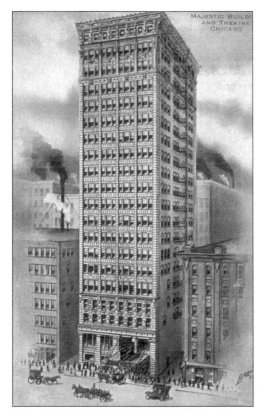

The Majestic, an elegant 22-story building, was constructed in 1905 at 16–22 Monroe Street. Like others of this period, it contained a theater. The foundation of the building consisted of 50-foot wood piles and rock caissons. C.A. Eckstrom was the architect.

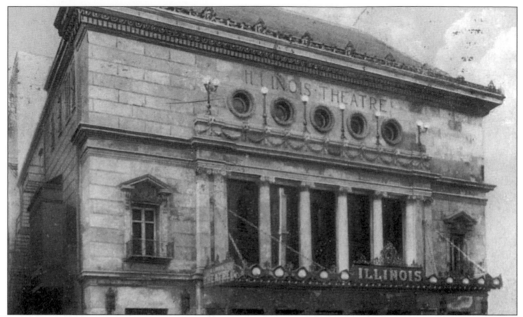

Charles B. Dillingham's *Watch Your Step,* with the famous dance team of Mr. and Mrs. Vernon Castle, was playing at the Illinois Theatre on Jackson Boulevard near Michigan Avenue in 1915. Mrs. Castle played herself, and her husband played a dance-step inventing fool by the name of Joseph Lilyburn. These two modern popular dancers made dancing the step featured in this show famous—the Fox Trot (1907)

Mary Miles Minter (Juliet Reilly) started her career in Chicago. She was associated with the American Film Company, which had studios at 6227 Broadway. Minter later went to Hollywood where she made about 12 films, one of which was *Anne of Green Gables* in 1919. Her Paramount Studio contract was canceled when her lover/director, William Desmond Taylor, was murdered in 1922, and she was labeled as a "loose" actress and possibly a murderess.

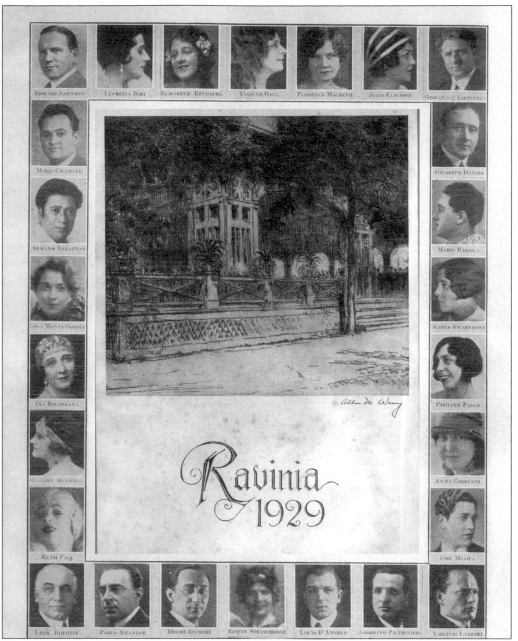

Ravinia, a wooded park located in Highland Park, became the summer home for opera in Chicago. During the 1920s, the world's great artists came here to perform, fighting the sounds of passing trains. The Chicago North Shore and Milwaukee Railroad Company picked up passengers at the Adams and Wabash Street station and delivered them to Ravinia in 45 minutes. Many attendees dined before or after the opera at the Sky Harbor Petrushka Club near Glencoe, enjoying dining, dancing, and the enjoyment of airplane thrills. In 1929, opera lovers got to enjoy performances of *La Rondine, The Sunken Bell, Fedora, Marouf, The Cobbler of Cairo, La Traviata,* and *Lucia di Lammermoor.* The artists who appeared in these operas are shown above.

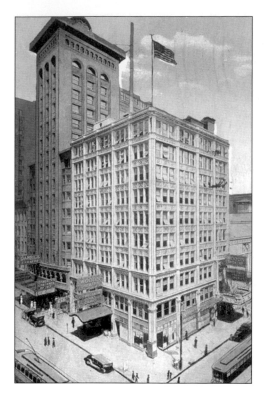

The famous Wood's and Garrick Theaters were located on the corner of Randolph and Dearborn Streets. Notice the fancy marquee and canopy entrances to the theaters. Playing at the Garrick in 1815 was a revue called *The Passing Show of 1915*. That show had ". . . 12 scenes of Splendor with Winter Garden Star Cast of 125, Including a Bounteous Exhibition of Feminine Pulchritude." Who could have asked for anything more? Col. Wood's Theater started out as a museum.

The Olympic Theatre, located on the corner of Randolph and Clark, was presenting A.H. Wood's *Kick In* with Richard Bennett in 1918. This theater was first called the New Chicago Theatre in 1875, when it was built by James H. McVicker. The postcard is promoting a play called *The Fortune Hunter* by Winchell Smith. Notice the early use of a revue by a newspaper critic to convince the public that the play is a winner.

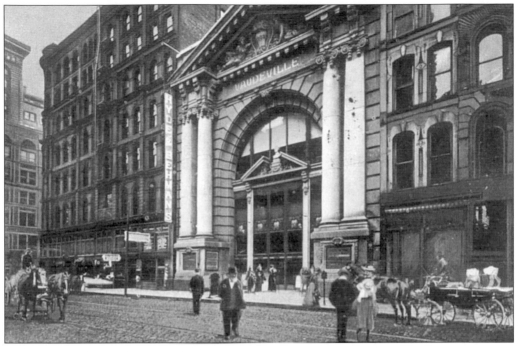

The Iroquois Theatre was on Randolph between State and Dearborn. Eddie Foy was on stage at a matinee performance in the theater on December 30, 1903, when an electric spark caught a curtain on fire. People panicked, fire doors were locked, and what should have been a minor fire resulted in 600 deaths. The name of the restored vaudeville house was Hyde & Behman's Music Hall.

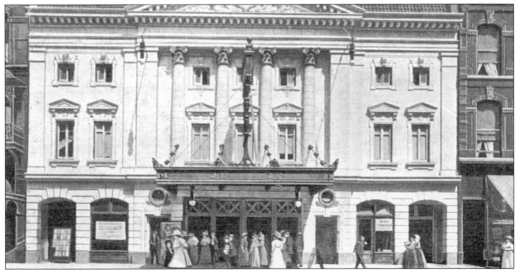

The Romanesque Princess Theatre was on Clark Street near Jackson Boulevard. It was built in 1903, and had three stories and a basement on a pile foundation. Kirchoff and Rose from Milwaukee were the architects. Playing at the Princess in 1915 was the smash hit *Just Boys*, which the *Chicago Daily News* described as "Thrills to tears. . . rings with laughter." In 1909, Chicago had 36 theaters.

Chicago's first piano virtuoso was Fannie Bloomfield-Ziesler. She was born in Germany but came to Chicago in 1886 with her parents. Although slight in physique, her playing showed great power. Bloomfield-Ziesler made her Chicago debut playing the Henselt *Piano Concerto*.

She also recorded piano rolls for the Chicago firm of Q.R.S., which was located in the Fine Arts Building. By the 1920s, piano rolls had turned high-tech. Three companies had perfected ways to record the dynamics of the artists' performances. All three companies had showrooms in Loop music stores. Bloomfield-Ziesler recorded for all three companies.

Special concerts were held by the Chicago Symphony Orchestra, featuring the piano rolls of Saint Saen's *Piano Concerto* recorded by Harold Bauer, with Bauer sitting in the audience and not in front of the roll-driven piano. J. Ogden Armour bought one of these specially equipped grand pianos and so did the Everleigh Sisters! Theirs was gold-plated!

Damrosch's opera company was not the only company presenting opera in Chicago in 1898. Appearing in the Grand Opera House that year was Fanny Davenport and her company, which performed plays and operas. She was the diva in *La Tosca* and *Cleopatra*. Boys went into the theater between acts selling boxes of chocolates for 35¢. You could also buy 10 Le Roy cigars for 10¢ in the lobby.

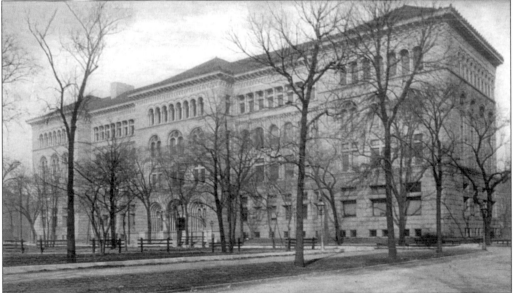

Upon his death, developer Walter L. Newberry left about $3 million to construct a research library. It was built on the former Ogden Block, which had a mansion on the site and was the only north side building to survive the Chicago Fire. The library was designed by Henry Ives Cobb. Inside its walls are millions of books with an emphasis on history, humanities, and genealogy. It also contains an extensive music collection.

By the 1920s, New Orleans' jazz had journeyed up river to Chicago. King Oliver, Jelly Roll Morton, and Louis Armstrong came to town and brought with them a music that Chicago would take to and mold into its own. Joseph King Oliver was playing at the Lincoln Gardens with his Creole Jazz Band with Louis Armstrong on trumpet. Jelly Roll Morton recorded 18 titles in Chicago with his Red Hot Peppers.

White musicians listened and learned. McPartland, Freeman, Krupa, and Goodman were in the Lincoln Garden audiences, readying themselves to carry jazz on to the next level. The Benson All Star and the Yellow Jackets Orchestras gave Chicago's dance halls and speakeasies what they craved—jazz, hot and heavy. Gangsters liked jazz because, as one said, "It got guts and it don't make you slobber."

Sally Rand added to the fun in 1933, when she appeared at the Century of Progress. Her carefully placed fans guarded, except for a brief instance at the end of her dance, a body made in heaven!

Six

THRILL FACTORIES
AND FAIRS

*O*nce *factories were designed to be run by machines, it did not take long for moneymakers to design machinery to amuse people. New York factory workers, who had tended demonic machines all day long, flocked to one of the great amusement parks on Coney Island on their weekend day off to have machines thrill them and scare them.*

Chicago developed thrill factories also. Actually, the birthplace of the modern amusement park was not Coney Island but Chicago. Paul Boyton came to Chicago in 1886 to appear in a water show exhibition at Cheltenham Beach, Chicago's first amusement park. His water show ran for one year, but in 1894, he designed his own park using complicated mechanical rides. His special water chutes ride was the hit of his park, which was located at 61st Street and Drexel Boulevard. In 1895, Boyton took his park ideas to Coney Island and built its first park, Captain Boyton's Sea Lion Park and Water Circus. Here, too, the water chutes were the talk of the island. He later franchised this ride to all amusement parks in the country. The rides at America's new amusement parks were much the same—Ferris' wheels and roller coasters known as coasters. At the time, Coney Island bragged about having three great amusement parks, but Chicago had five!

Chicago built coliseums during these days to hold banquets, trade shows, political conventions, and flower shows. Chicago was constantly experimenting and upgrading its transportation networks to accommodate the huge crowds of people coming into the city.

This postcard shows the great exposition that opened on May 30, 1865, which was called the Great North Western Sanitary Fair. This is the main building of the fairgrounds, which drew visitors from surrounding states. Such "sanitary fairs" were held all over the northern states during the Civil War.

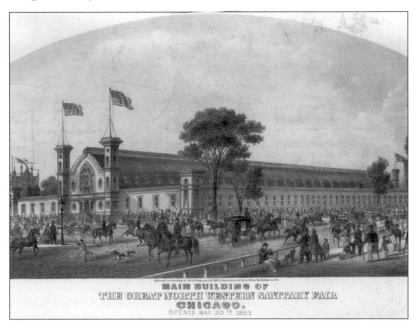

MAIN BUILDING OF
THE GREAT NORTH WESTERN SANITARY FAIR
CHICAGO.
OPENED MAY 30th 1865

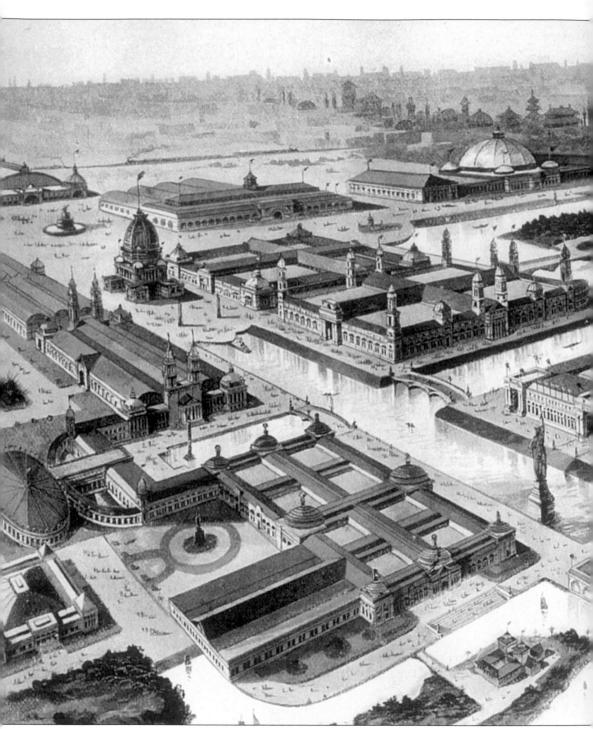

The World's Fair in 1893 was the biggest event to ever hit town. Chicago's greatest designers and architects, including Olmsted, McKim, Post, Cobb, Sullivan, Hunt, St. Gaudens, and Taft, met in 1891 to discuss how the buildings should look and be located. St. Gauden later called these meetings "the greatest meetings of artists since the fifteenth century."

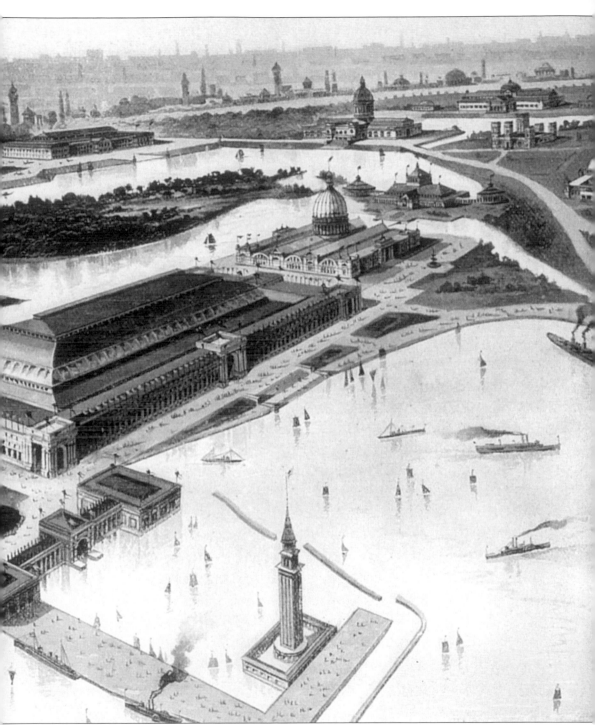

The building exteriors were left white to save money. To keep them white, the city made it illegal to burn coal within a 3-mile radius of the fair. The most memorable person to attend the fair was not President Grover Cleveland, who opened the fair, but a belly dancer called Little Egypt.

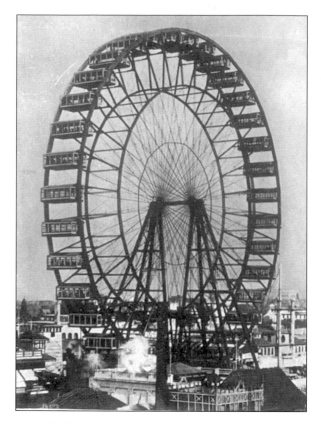

Ferris' giant wheel was the hit of the fair. It had enclosed viewing platforms that could accommodate hundreds of riders. The ride offered a spectacular view of the fair and the sprawling city. It was 265 feet tall and located on the Midway Plaisance.

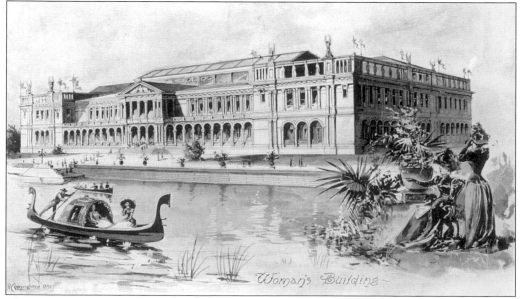

Woman's Building

The Woman's Building was the baby of Mrs. Potter Palmer and her all-state Board of Lady Managers. In addition to Mrs. Palmer's collection of rare and interesting artifacts, the building contained a model kindergarten where good childcare was taught and a kitchen where visitors were taught cooking methods. There were also concerts of music by female composers.

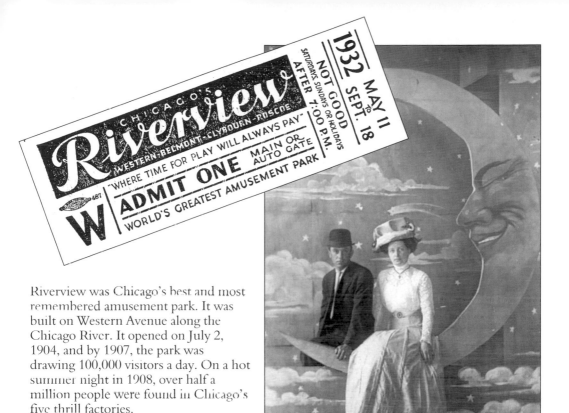

Riverview was Chicago's best and most remembered amusement park. It was built on Western Avenue along the Chicago River. It opened on July 2, 1904, and by 1907, the park was drawing 100,000 visitors a day. On a hot summer night in 1908, over half a million people were found in Chicago's five thrill factories.

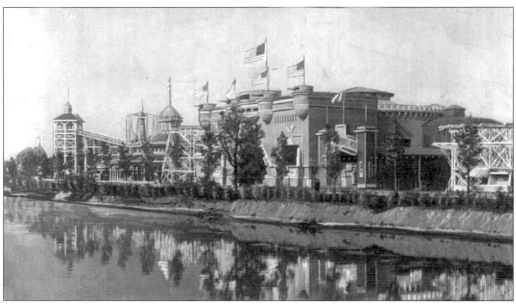

This early postcard of Riverview shows part of the park's Velvet Coaster, Naval Battle Building, and Chutes. Other rides and shows popular at the park were The Great Train Robbery with 150 actors and 30 horses, Scenic railway, Big Otto's Trained Wild Animal Show, Roller Rink, Kryl's Band, and Water Carousel.

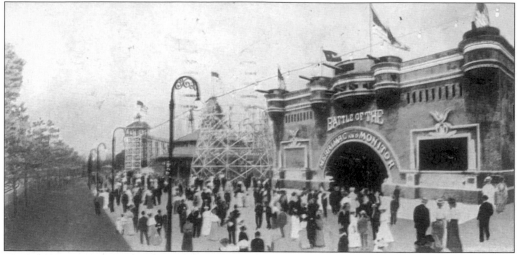

If you walked around to the front of the Riverview buildings shown on the previous card, this is what you would see on the "beautiful marine causeway." Perhaps the gun turrets on top of the building fired to attract new visitors before each showing. This "battle spectacular" was said to have cost $240,000 to build.

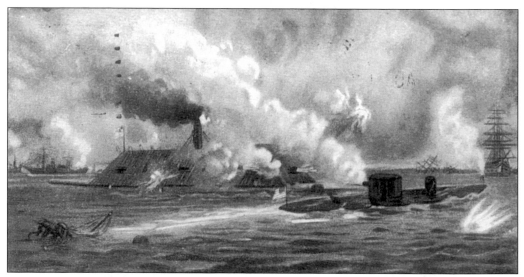

Here is the principal scene in the battle between the *Monitor* and the *Merimac*, two rival ironclads used during the Civil War. Other spectacular events staged at Riverview during this time was the "Burning of Rome" (the burning of Chicago was too close to home!) and the "Victory of the United States Fleet in the Spanish-American War."

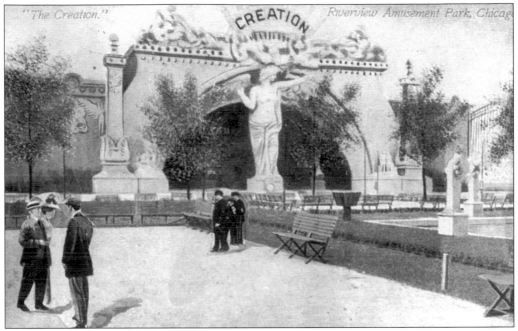

"The Creation." CREATION Riverview Amusement Park, Chicago

To cash in on those visitors of a religious nature, most amusement parks had special "uplifting and educational" shows. This card shows Riverview's "Creation" exhibit. In order to attract the attention of the crowd, huge scantily dressed sculptures of biblical characters appear outside the entrance. Coney Island parks had similar attractions.

This card from a later period shows a special wedding that was actually held on the Par-O-Chutes Jump for publicity to spike attendance. Amusement parks were very American. They were open to all whether low brow or high brow, rich or poor. Chicago's cultural diversity was never more evident than at the city's amusement parks, beach fronts, parks, and festivals.

The miniature railroad was also a great attraction at Riverview. Notice the Moorish building in the background and the park-like landscaping. Amusement parks were even more exciting at night when millions of lights illuminated the roller coaster, tunnel of love, and freak side shows. Magic was in the air. You could see and feel it!

Adolph Rudy
Meskow Church

When men visited Riverview and wanted a picture taken, sitting together on the Man in the Moon was not an option. What better backdrop than that of a locomotive. Shown here running "old 999" are three of Chicago's most eligible bachelors out on the town.

Some say that White City in its glory days was even better than Riverview. It's name came from the 1893 World's Fair. Lights were what White City was all about, for in the evening the outlined buildings created an atmosphere of excitement and adventure. Its Jewel Tower was the tallest building south of the city. The park was at 63rd Street and South Park Avenue.

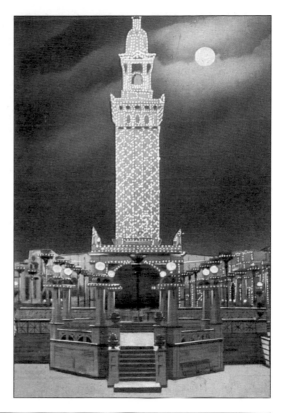

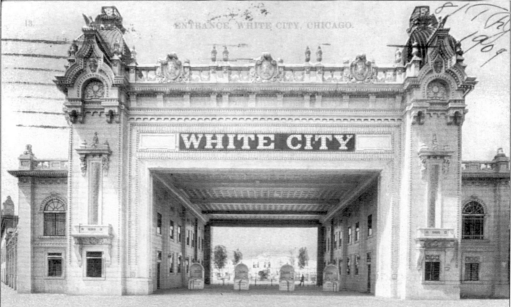

White City opened its gate in 1905. One of the first-day attractions was a group of trained elephants. Thousands of first-day visitors crowded through this gate to be transported into a magical dream world and fun factory. The fun house had a huge reclining clown over its entrance (1909).

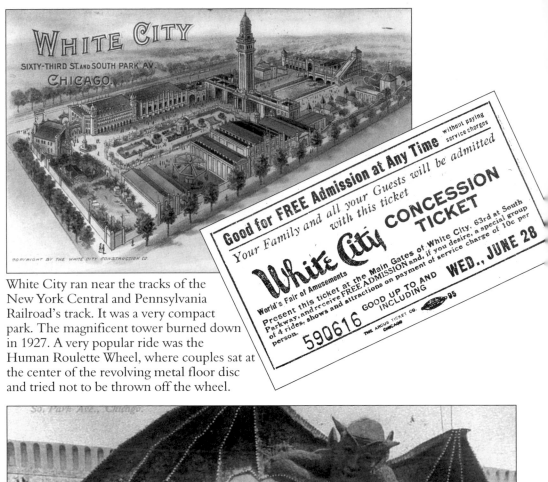

White City ran near the tracks of the New York Central and Pennsylvania Railroad's track. It was a very compact park. The magnificent tower burned down in 1927. A very popular ride was the Human Roulette Wheel, where couples sat at the center of the revolving metal floor disc and tried not to be thrown off the wheel.

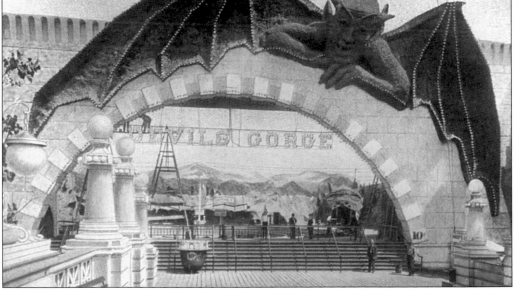

This entrance to White City's Devil Gorge is a magnificent example of amusement park art. The winged devil is there to dare visitors not to take the wild river ride. Of course, this threat of death was what made the ride so popular and exciting—especially for the young people. A great chance to squeeze and be squeezed by your date.

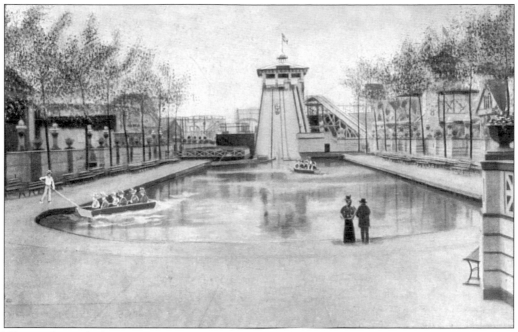

Water rides and adventures were an important part of every amusement park. Tunnels of love, aquatic shows, and Boynton's water chutes were all part of the parks. This postcard shows the Shooting the Chutes ride, which ended when the boatman pulled you to shore.

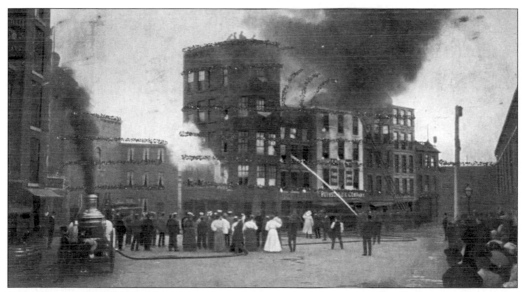

Water was part of the thrill, but creation of fire was even more exciting. This view shows the Fire Show at White City, which resembled all amusement park fire shows. A group of fireproof buildings was set on fire, and the actors anxiously await the fire department and the brave firemen to put out the fire. Notice that this card has silver sprinkled on roof and floor lines of the building.

Another of Chicago's great amusement parks during its Opulent Era was called Luna Park. Coney Island also had a Luna Park. This park was built on the site of a picnic grove at 50th and Halsted. One of its colorful owners in 1908 was James O'Leary, son of Chicago Fire's Mrs. O'Leary! Luna closed in 1911. This young lady was photographed on the Fourth of July in 1910.

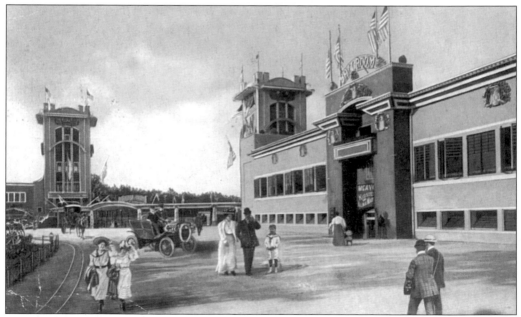

Forest Park, another amusement complex, opened in 1908, and drew people from Chicago's West Side. This postcard shows the ballroom building on the right and the tracks of a miniature railroad on the left. The park had an enclosed Dentzel carousel and a Terror of the Ocean ride, which cost 10¢ for adults to ride and 5¢ for children.

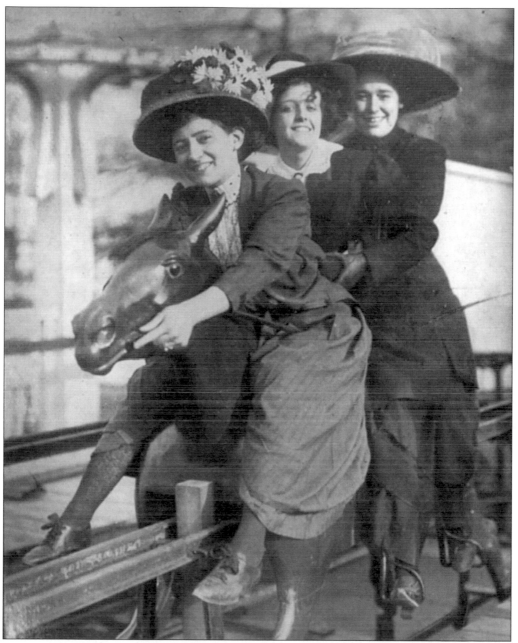

This park had the only real steeplechase ride outside of Steeplechase Park on Coney Island in 1910. An engineering marvel in its day, this ride allowed one or two riders to travel over a large tracked raceway with all kinds of curves, almost like a roller coaster. This posed picture shows three girls on a horse having the time of their life. The girl in front would not be allowed to ride with no stirrups. Another technically advanced amusement at the Forest Park was a working model of a subway run on compressed air. New York experimented with such a system, but it was never completed. The Forest Park model moved passengers in capsules through a tunnel. The principle was used, however, to move documents between banks in cities and in department stores to transfer money upstairs. Today we use it at drive-up banks.

Having your picture taken was almost an obligatory part of the amusement park adventure. Here we see two couples who visited Forest Park and had their portrait taken in front of a fake Burlington Railroad car. From all appearances, this was not a happy night out. The young lady on the right is particularly disappointed with what should have been a night of romance and adventure.

Here is a spectacular night view of the Forest Park Casino. Casinos were legal at this time in Chicago. It was only later that they were made illegal in an attempt to control organized crime. Once again we see an example of how night-lights were used to attract attention and to encourage people to part with their money.

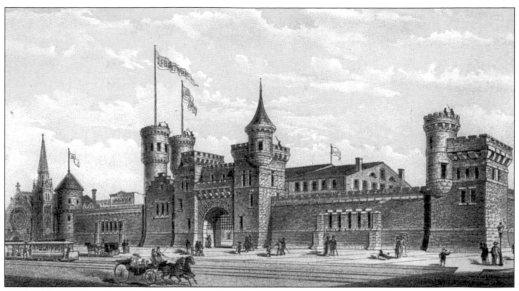

The Confederate Libby Prison was transported from Richmond, Virginia, to Chicago in 1889, and made into a war museum. Located on Wabash between 14th and 16th Streets, a dome was added in 1910. Later, the former prison served as a convention center and a gathering place for special events in the city.

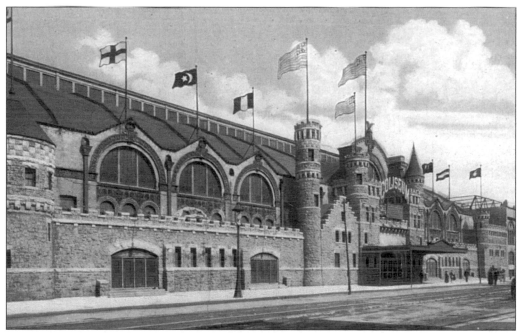

Enclosing the building's courtyard changed the look of the building. Now the building became a mix of Medieval and Romanesque styles. Note the flags of many nations flying on the building. This was the McCormick Place of its age.

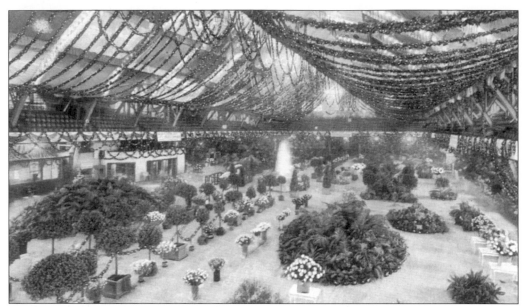

The Coliseum, as it was renamed, was the site of five successful Republican National Conventions. Flower shows were also held in the expansive hall. "Hinky Dink" Kenna and John "The Bath" Coughlin, illustrious politicians, gave a First Ward Ball here in 1908. Their dates were the Everleigh sisters. When too many people showed up, there was a riot. "Dink" said, "It's a lollapalooza. . . Chicago ain't no sissy town."

Chicago's Century of Progress Exposition opened on April 29, 1933. It covered 400 acres on the lakefront where no land had existed before. Daniel H. Burnham Jr., whose father had been in charge of the architecture of the 1893 Fair, was the secretary of this new look at technology and the future. This aerial view shows the grounds and buildings.

While the 1893 Fair buildings had facades drawn from the past, this fair's were sleek and powerful in nature. In their own way, they too were opulent, breathtaking, and loaded with shining originality. The Havoline Thermometer Building was functional architecture at its best (1933).

Ripley's Odditorium resembled a Mexican Indian temple and was loaded with an updated version of the old carnival freak show. Small people were always a draw, as was Sing Lee who could blowtorch his face and live. Also featured were Betty Williams, who had an extra set of legs and hips, and Orpha Ensign and Ray Bard, who were living skeletons. Ripley produced a whole packet of postcards for sale.

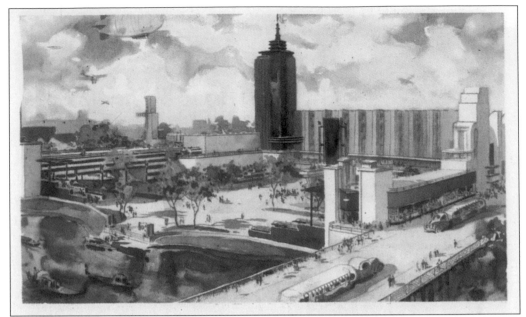

This postcard shows the Hall of Science in which basic science exhibits were housed at the Century of Progress International Exposition. Overhead hovers the Goodyear blimp as it often did on many other cards from this fair. The architectural styles featured here very much correspond to all the other art forms of the 1930s.

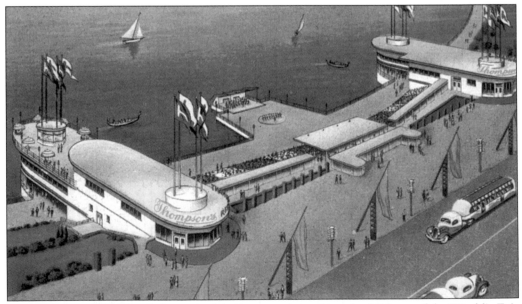

The "Avenue of the Flags" shown in this view corresponds to the Midway of the World's Fair of 1893. It was the main promenade for visitors. Thompson's Restaurants were of a clever design, which fit well on the lakefront. The restaurants give the appearance of ferryboats that have been rammed into the shore. Notice the band shell thrust out into the lake.

INDEX